CRUSH + COLOR

THE ROCK

**A Coloring Book of Fantasies
With a Powerful Charmer**

www.castlepointbooks.com

The Castle Point Books trademark is owned by Castle Point Publishing, LLC.
Castle Point books are published and distributed by St. Martin's Press.

978-1-250-27039-9 (trade paperback)

Illustrations by Maurizio Campidelli
Design by Joanna Williams
Edited by Monica Sweeney
Special thanks to Jennifer Calvert

Our books may be purchased in bulk for promotional, educational, or business use.
Please contact your local bookseller or the Macmillan Corporate and Premium Sales Department
at 1-800-221-7945, extension 5442, or by email at MacmillanSpecialMarkets@macmillan.com.

First Edition: 2021

10 9 8 7 6 5 4 3 2 1

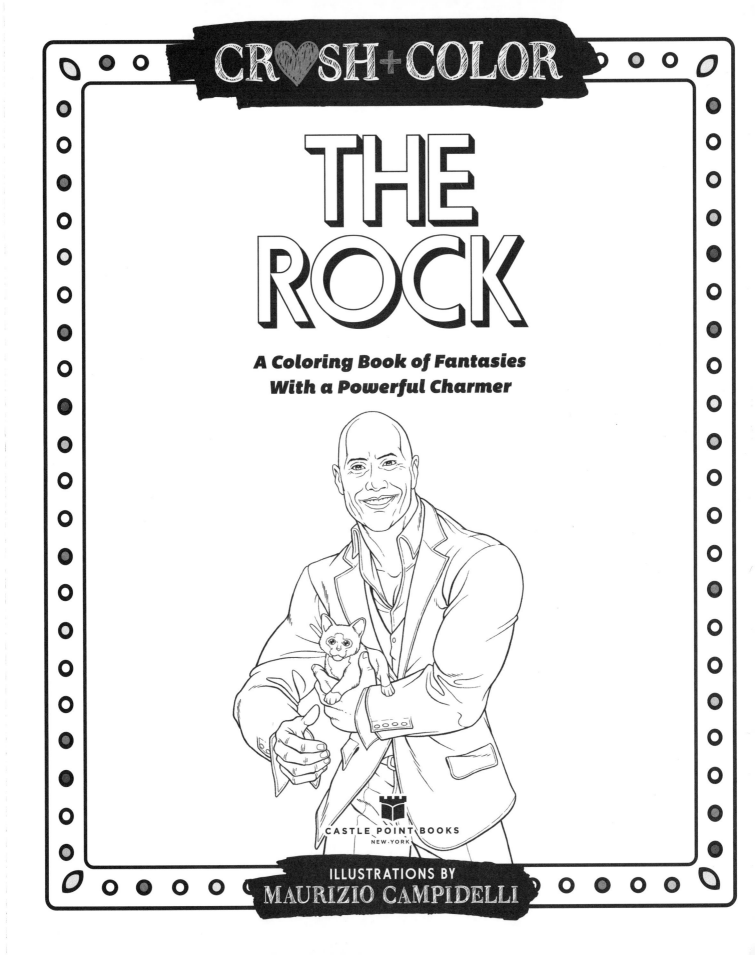

CRUSH + COLOR

THE ROCK

**A Coloring Book of Fantasies
With a Powerful Charmer**

CASTLE POINT BOOKS
NEW YORK

ILLUSTRATIONS BY
MAURIZIO CAMPIDELLI

○ ○ ○ ○ *In Your Dreams* ○ ○ ○ ○

Raise your eyebrow to this morning delight. As the sweet maple cascades down this tall stack, you will wonder if this is all the sugar he needs, or if he is just getting started. Enjoy a blissful morning together as you fuel up for a day of high-octane fun. You're going to need it, because The Rock never loses his steam.

CRUSH ON THIS KNOWLEDGE

You might think Dwayne follows a strict diet, but the body-builder went viral in 2016 for posting a video on Instagram of him making his "world-famous" chocolate-chip pan-cakes after work. He likes his extra sweet, opting for milk-chocolate chips and topping them off with whipped cream.

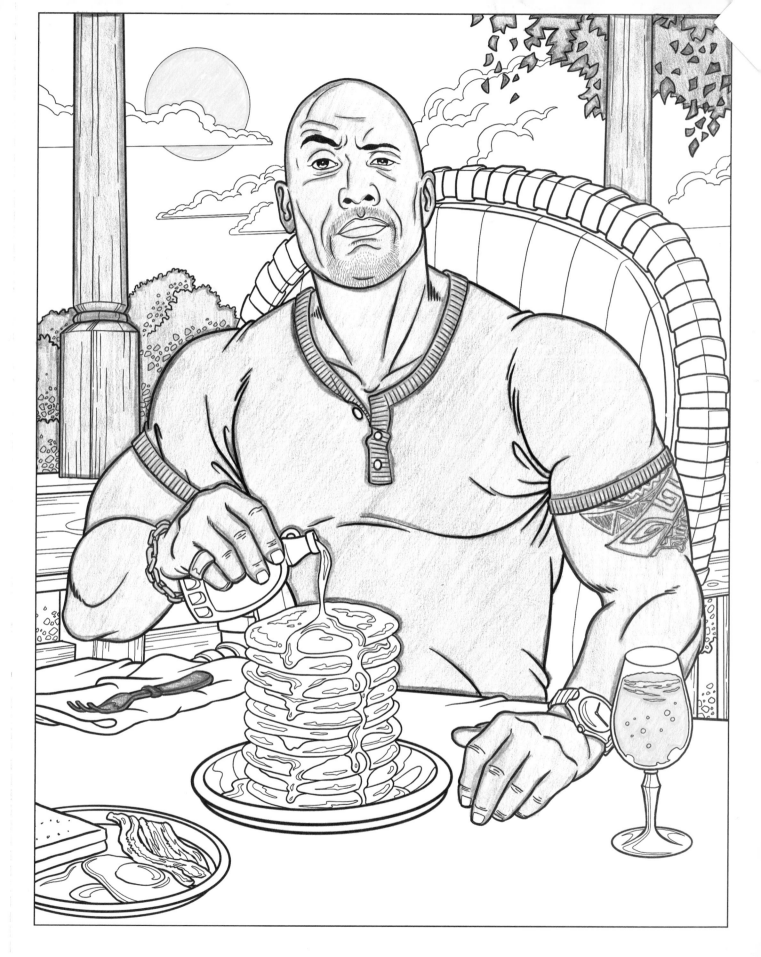

○ ○ ○ ○ *In Your Dreams* ○ ○ ○ ○

Is that the ocean that's sweeping you off your feet, or is it The Rock's tidal charm? He'll race to your rescue like a true gentleman, but he's so comfortable in his masculinity that he'll cheer you on rather than be put out if you outfox those waves yourself. As he runs down the shoreline with his life preserver in hand, he'll keep an eye out for sandcastles to build, wildlife to protect, and hearts to melt.

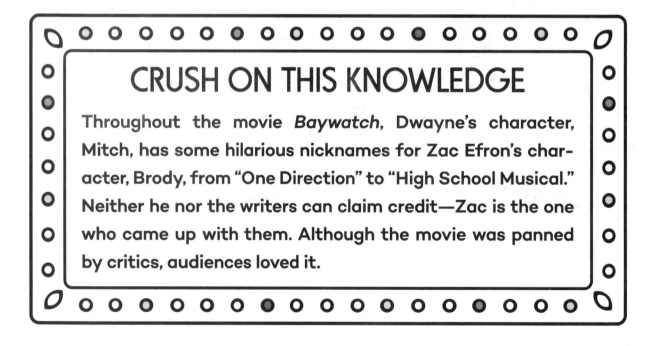

CRUSH ON THIS KNOWLEDGE

Throughout the movie *Baywatch*, Dwayne's character, Mitch, has some hilarious nicknames for Zac Efron's character, Brody, from "One Direction" to "High School Musical." Neither he nor the writers can claim credit—Zac is the one who came up with them. Although the movie was panned by critics, audiences loved it.

∘ ∘ ∘ ∘ *In Your Dreams* ∘ ∘ ∘ ∘

It might be a hot one on these sunlit dunes, but this is no mirage. The Rock will have you revving your engine while you explore sandy hills and new horizons. Let your heart race and your adrenaline pump as you bound along this thrilling route. There is no hill too high or descent too steep when The Rock is in charge, and he knows how to handle curves. As the wind blows through your hair, take a moment to savor the exhilarating escapades that await you whenever The Rock is around.

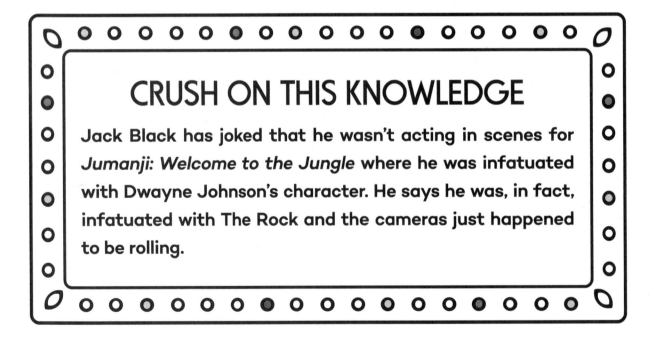

CRUSH ON THIS KNOWLEDGE

Jack Black has joked that he wasn't acting in scenes for *Jumanji: Welcome to the Jungle* where he was infatuated with Dwayne Johnson's character. He says he was, in fact, infatuated with The Rock and the cameras just happened to be rolling.

○ ○ ○ ○ *In Your Dreams* ○ ○ ○ ○

It's a beautiful day for solitude and serenity with The Rock as your stunning sweetheart. While his glistening skin and hard-won muscles may be a source of distraction, be polite enough not to ogle. He'll remind you of his caring nature by insisting you stay hydrated with a freshly plucked coconut. Watch the tide roll in together and let the day's cares wash away with each crashing wave. Sit back and relax in a paradise like no other with this dreamy companion.

CRUSH ON THIS KNOWLEDGE

Dwayne takes his films and team's time seriously. In September 2020, he ripped down his driveway gate using his bare hands when it was stuck shut during a power outage. He "did what [he] had to do" so that he would not let down the hundreds of production crew members on set who were waiting for him.

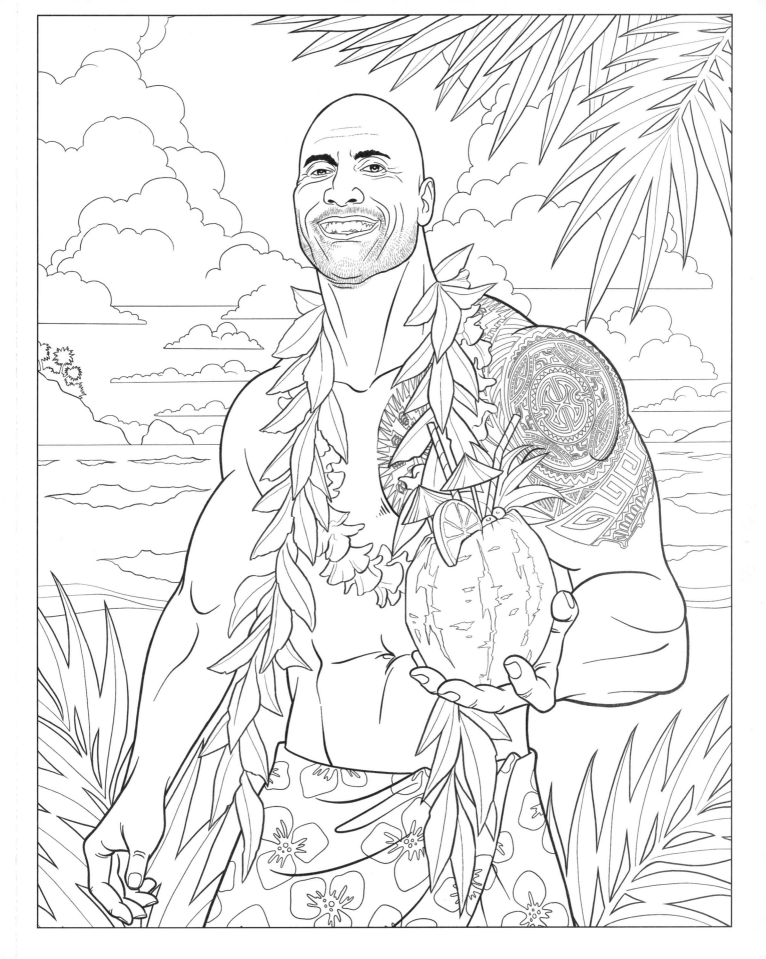

○ ○ ○ ○ *In Your Dreams* ○ ○ ○ ○

There is no one who exudes strength and stamina quite like The Rock, but no amount of sweat will keep him from being sweet. As he lifts his impressive weights, tosses around hefty chains, and gets his blood pumping to build his power, he's wondering how he can be an everyday superhero who slays negativity and brings smiles to everyone's faces. Crush on his strength as he crushes his workout with enduring intensity and dedication.

CRUSH ON THIS KNOWLEDGE

Dwayne started working out as a way to feel in control of his life. He and his mother had been evicted from their efficiency a week after their car was repossessed. "That was the tipping point," he says. "It was about, 'What can I control with these two hands?'"

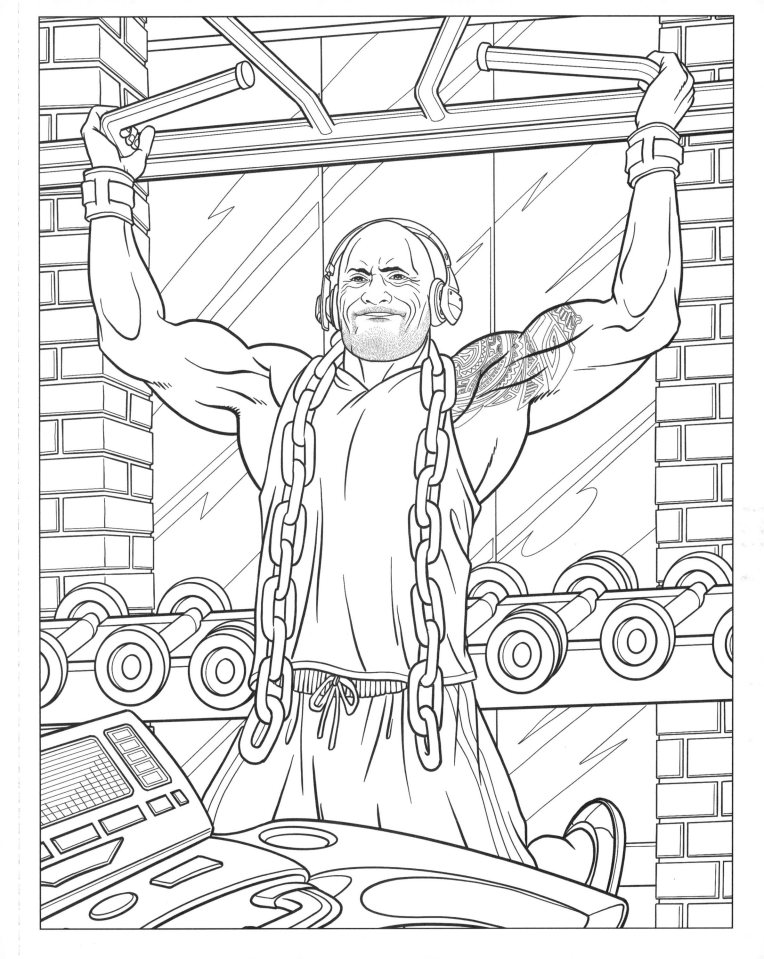

In Your Dreams

It's the call of the wild and you know just who is the center of attention. The Rock's strongman look is no mask for his sweetheart demeanor, and these cuddly creatures have picked a good one out of a crowd. He'll offer the gentle touch of a butterfly and the playful heart of a pup, but The Rock's good nature is all his own.

CRUSH ON THIS KNOWLEDGE

It's no secret that Dwayne "The Rock" Johnson is a big softie at heart, so it should come as no surprise that he's also an animal lover. And from beluga whales at the Georgia Aquarium to his own pupper, a French Bulldog named Hobbs, they seem to love him back.

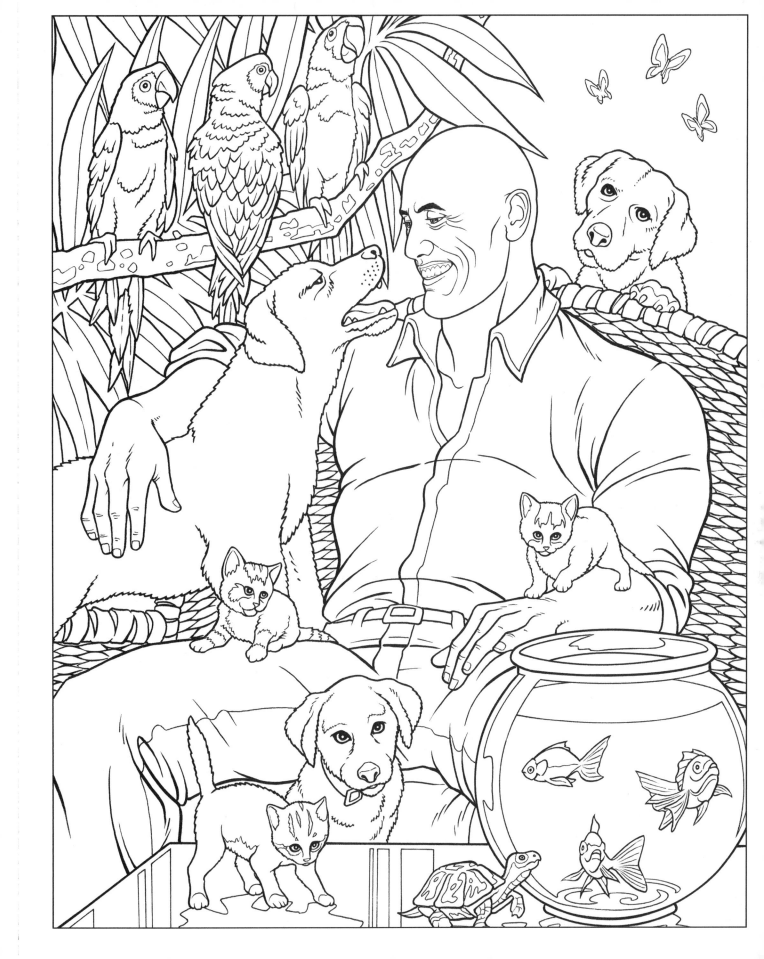

○ ○ ● ○ *In Your Dreams* ○ ○ ● ○

He'll scale dangerous cliffs, traverse the highest mountains, and cross the wildest jungles, but The Rock's most exciting adventure is being right here with you. Wander the forest together and discover the mysteries of Mother Nature. She'll impress you with the smoke and ash of a mighty eruption far off in the distance, and all the while you'll be thinking that there's nothing more awe-inspiring than The Rock in all his glory.

CRUSH ON THIS KNOWLEDGE

Dwayne was in Budapest filming *Hercules* when he received the script for 2015's *San Andreas*. He stayed up until 3:30AM to read it because he was so excited about it. In the months leading up to playing Hercules, he would have been waking up around then to work out.

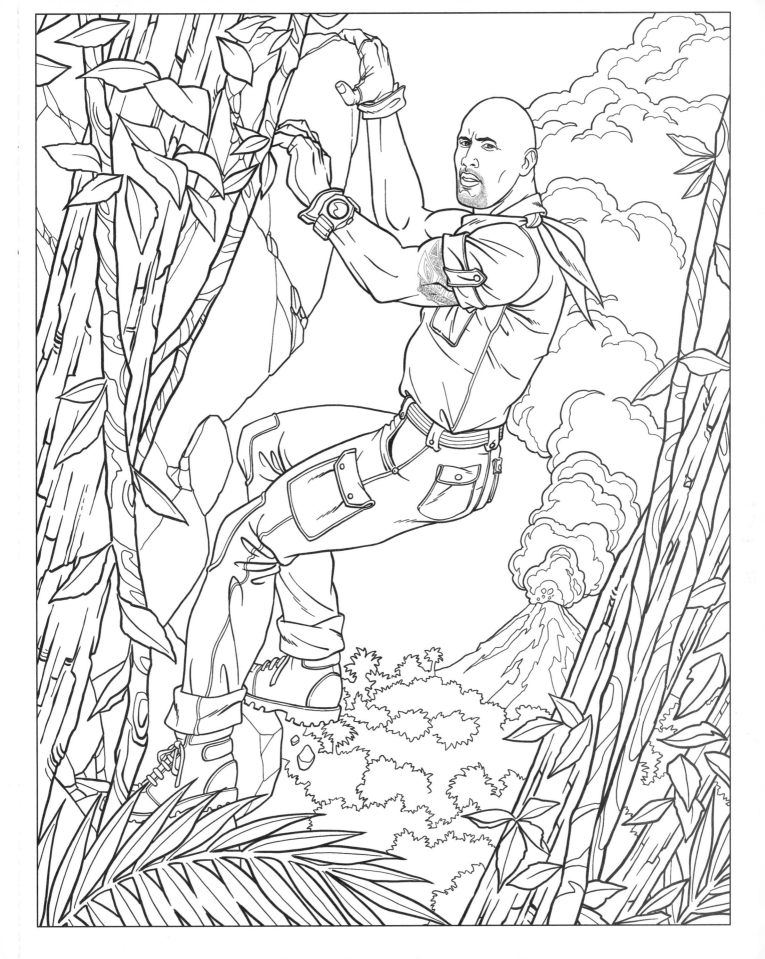

○ ○ ○ ○ *In Your Dreams* ○ ○ ○ ○

Embrace more artistic pursuits and let this handsome gentleman take the pottery wheel. With a tender touch and the patience of an angel, The Rock will find himself mastering yet another impressive craft. His quiet intensity and mindful concentration bring a moment of zen and tranquility to a chaotic day. But as his steady caress molds and shapes the clay to his desires, he will be thinking just how he can mold a better and more harmonious world.

CRUSH ON THIS KNOWLEDGE

For a man who calls himself "The Rock," Dwayne has no problem showing his softer side—especially when it comes to his daughters. In one heart-melting viral video, he shows his then-two-year-old daughter Tiana how to wash her hands while singing along to Maui's rap from *Moana*.

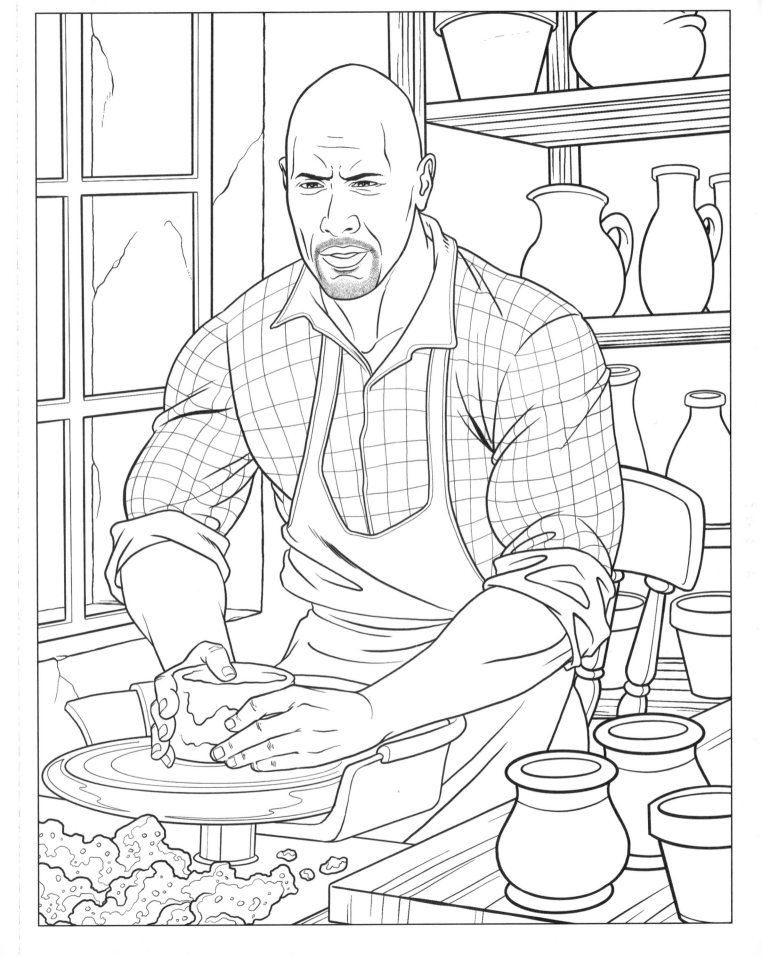

○ ○ ○ ○ *In Your Dreams* ○ ○ ○ ○

Let your daydreams flourish in this garden of Eden. No stranger to hard work, The Rock will get his hands dirty and work up a sweat to turn this blossoming garden into the lush paradise it was intended to be. Smell the flowery perfume of nature in bloom, hear the buzz of bees in search of nectar, and witness the greenery swaying along with the cool breeze. It's just another perfect day when this force of nature is nearby.

CRUSH ON THIS KNOWLEDGE

Dwayne brings the thunder not just to his acting pursuits, but to causes he cares about by frequently supporting conservation efforts and charities. When a UK nonprofit reached out about their effort to plant up to 20,000 trees—one for each new follower—he immediately responded that he would help fund the entire project.

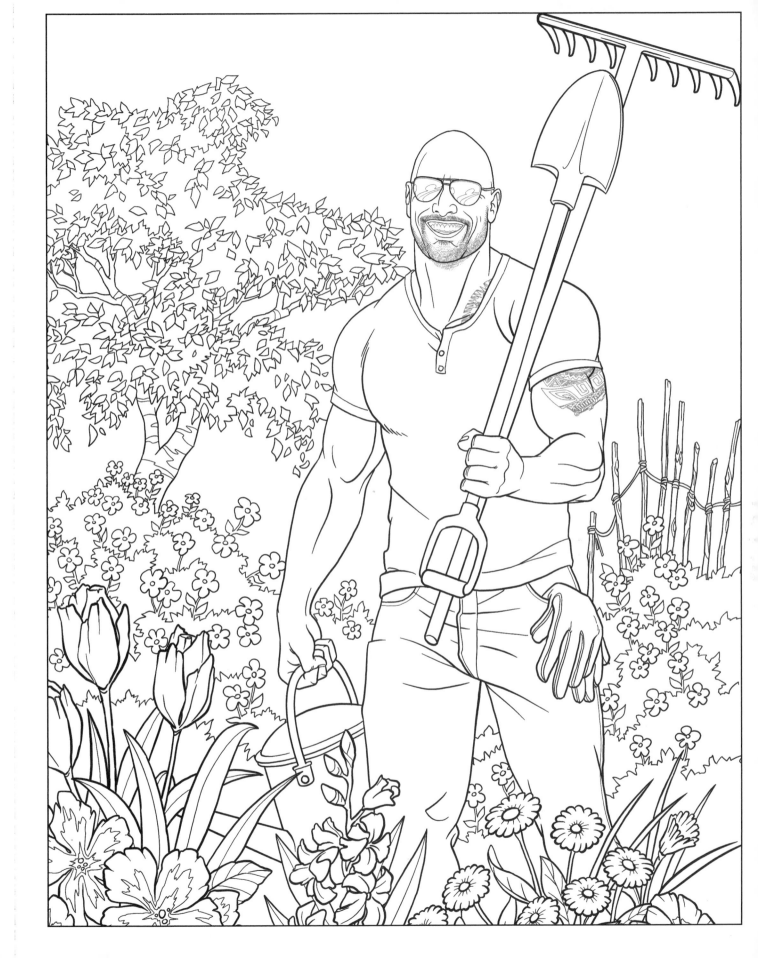

In Your Dreams

Masculinity is the game and The Rock is his name during this back-yard scrimmage. He'll send this pigskin soaring with all his might, but he'll pass and work with his teammates because he's not going to hog the limelight. As he shows off his love of the game and gives each play his all, he'll reserve enough energy to work his adoring crowd. Watch his playful spirit in action as he wins big.

CRUSH ON THIS KNOWLEDGE

Like his character in *The Game Plan*, Dwayne was a natural at football. A teacher encouraged him to try out for the sport in high school, and he soon earned a scholarship to study at and play for the University of Miami. He suffered injuries before he could make it to the NFL.

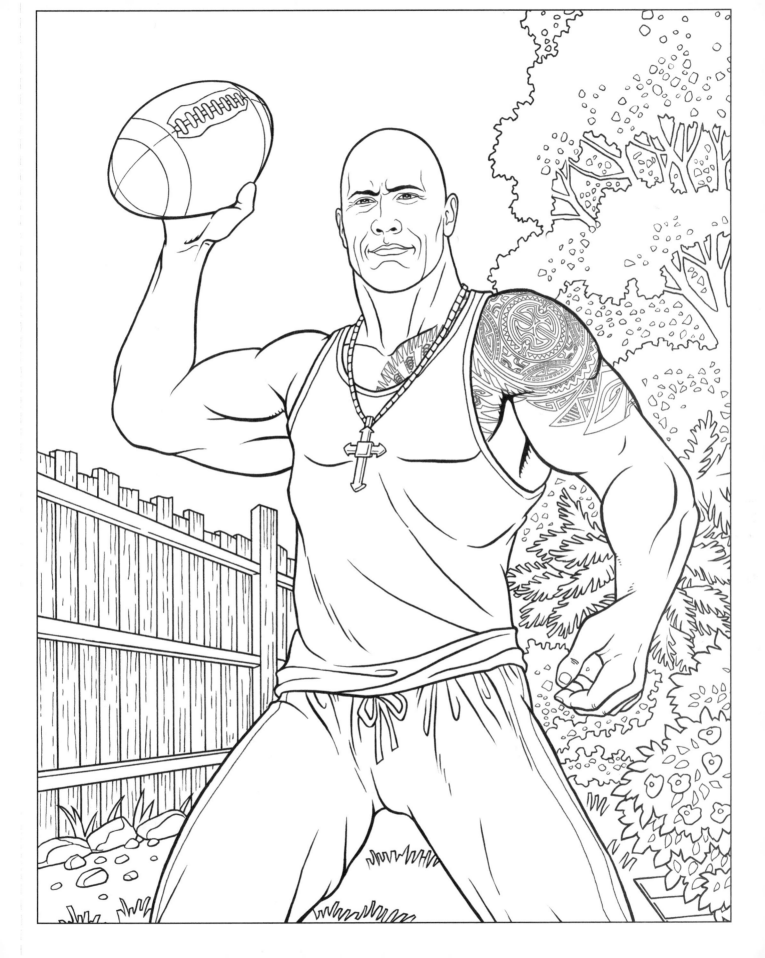

In Your Dreams

You might get hooked on The Rock, but he is the real catch. In this aquatic dreamland, he'll sail open waters and get lost in the transfixing sound of his fishing line cast out to sea. He won't be tempted by just any fish but will spend the day waiting for just the right haul. His rugged strength and determination make him a patient fisherman, and when he brings in the perfect catch, he'll be sure to handle it with care.

CRUSH ON THIS KNOWLEDGE

Dwayne is an impressive fisherman, and his biggest catch yet was a 200-pound tarpon. But his pride and joy are the bass he raises on his farm. He even has specialists inspect the ecosystem to ensure the bass are at the top of their game when he hooks them.

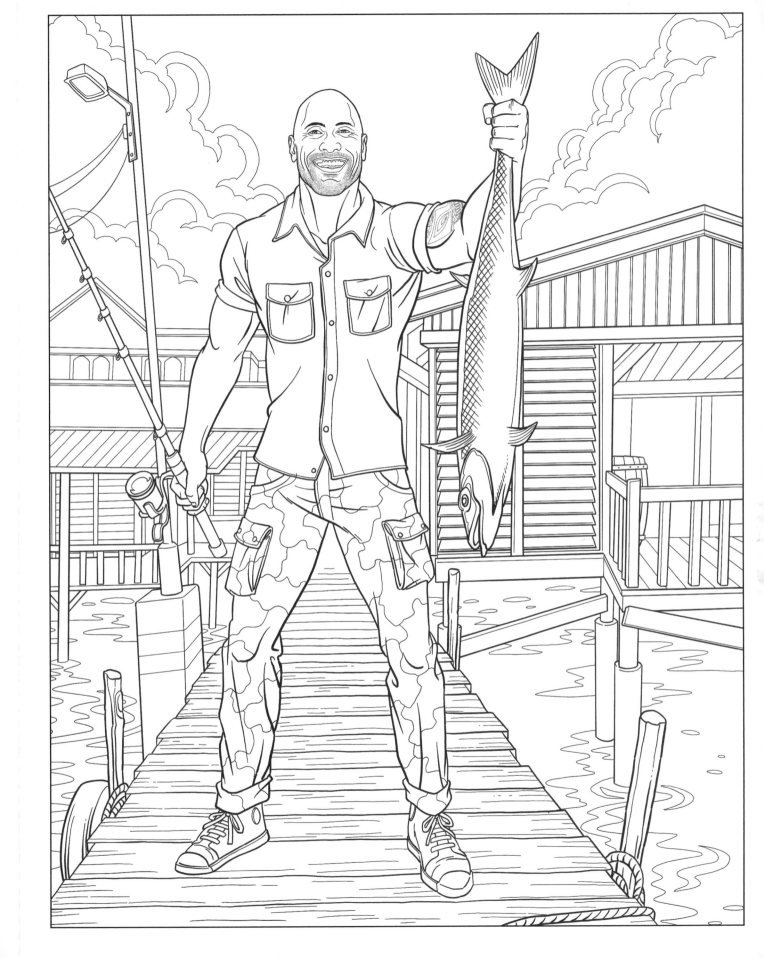

In Your Dreams

The stadium lights are bright, the crowd is going wild, and the ring is on fire because The Rock is in action. He'll show his ferocity and play bad to rile you up, but he can't go too long without letting his signature smile and his alluring kindness shine through. He wouldn't hurt a fly in his quest for greatness, but he might break hearts along the way.

CRUSH ON THIS KNOWLEDGE

Dwayne is a third-generation wrestler. His dad, Rocky Johnson, was a National Wrestling Alliance (NWA) Georgia Champion and a member of the first Black tag team to win the World Wrestling Federation's Tag Team Championship. His grandfather, Peter Maivia, was an NWA Hawaii heavyweight champion.

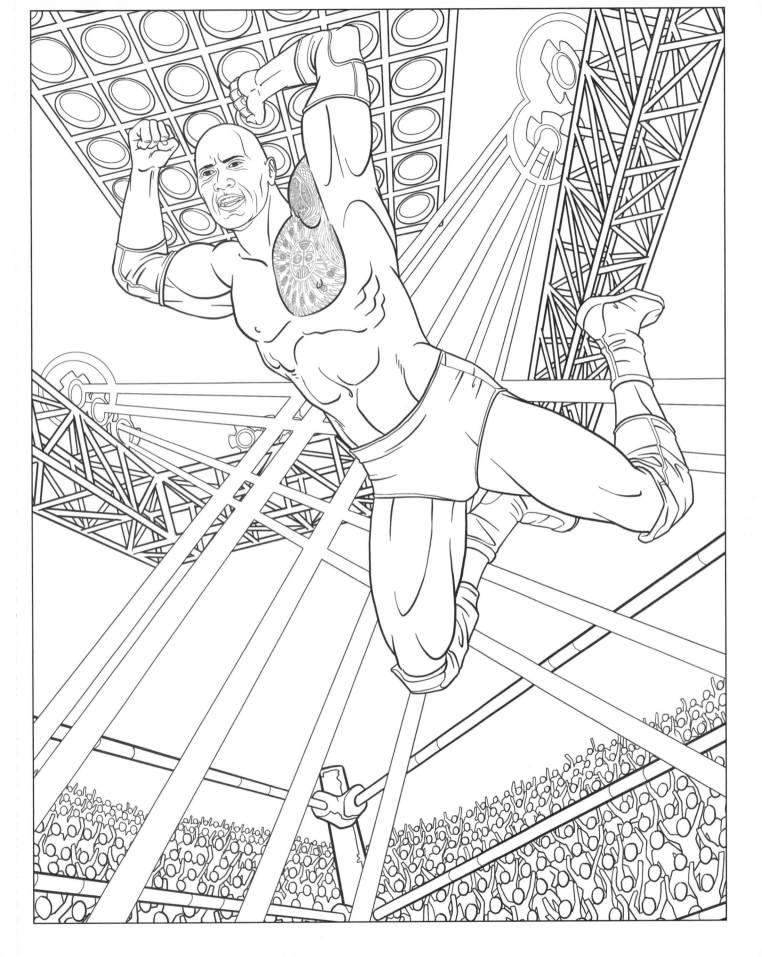

In Your Dreams

Raise a glass to a man who has a taste for the finer things. As he relaxes at a seaside bar with the waves crashing behind him, he'll sip away at his very own tequila. This is a man who knows how to drink his spirits, but it might be his entrepreneurial spirit that's even more impressive. Let him walk you through the flavors of each sip—you'll enjoy its gentle fire, just as you'll feel the heat of the fire between you.

CRUSH ON THIS KNOWLEDGE

For his 49th birthday in May 2021, Dwayne Johnson created a promotion to help bring business back to pandemic-affected restaurants. He offered up to a million dollars' worth of free guacamole to customers who purchased it with any drink made with Teremana tequila (the company he co-founded).

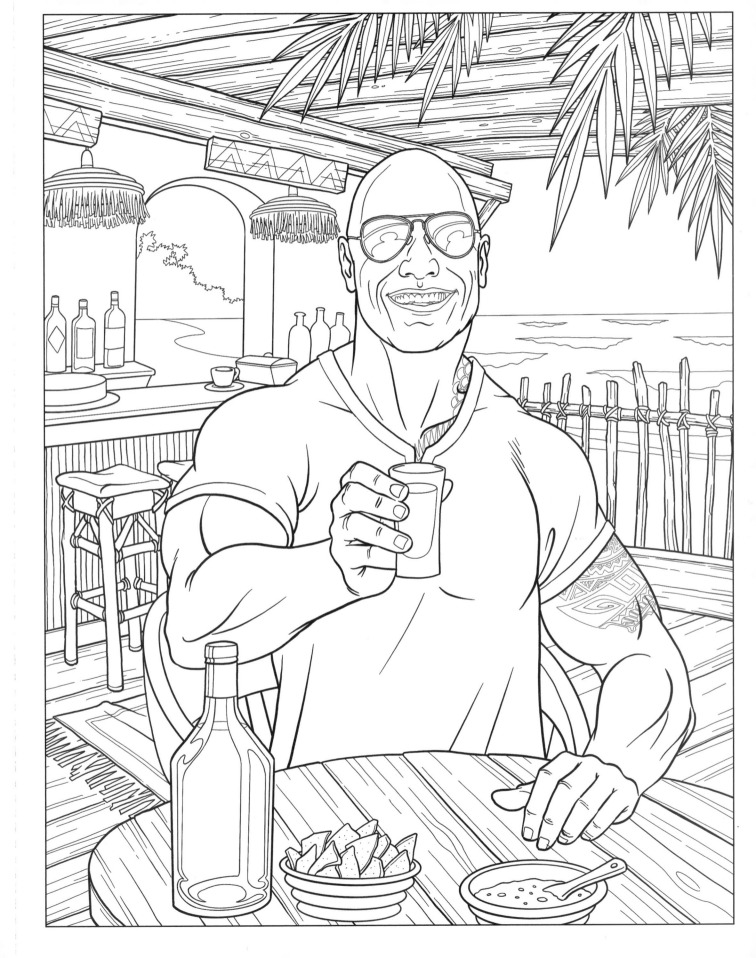

○ ○ ○ ○ *In Your Dreams* ○ ○ ○ ○

Smell what The Rock is cooking you for dinner on this romantic evening. He'll raise your appetite and you'll be drawn to him as the aromas waft through the air—and it's all a part of his plan for the perfect date night. You'll find him over the stove, savoring every flavor so he knows he's getting them just right for you. Ever the gentleman, he'll insist that you relax and unwind to get ready for the dinner of your dreams.

CRUSH ON THIS KNOWLEDGE

When Dwayne started out in professional wrestling, he chose the stage name "Rocky Maivia"—a combination of his father's first name and his grandfather's last name. But when fans rejected his nice-guy persona, he rebranded himself as a villain. "The Rock" (and his famous catchphrase) became the stuff of WWE legends.

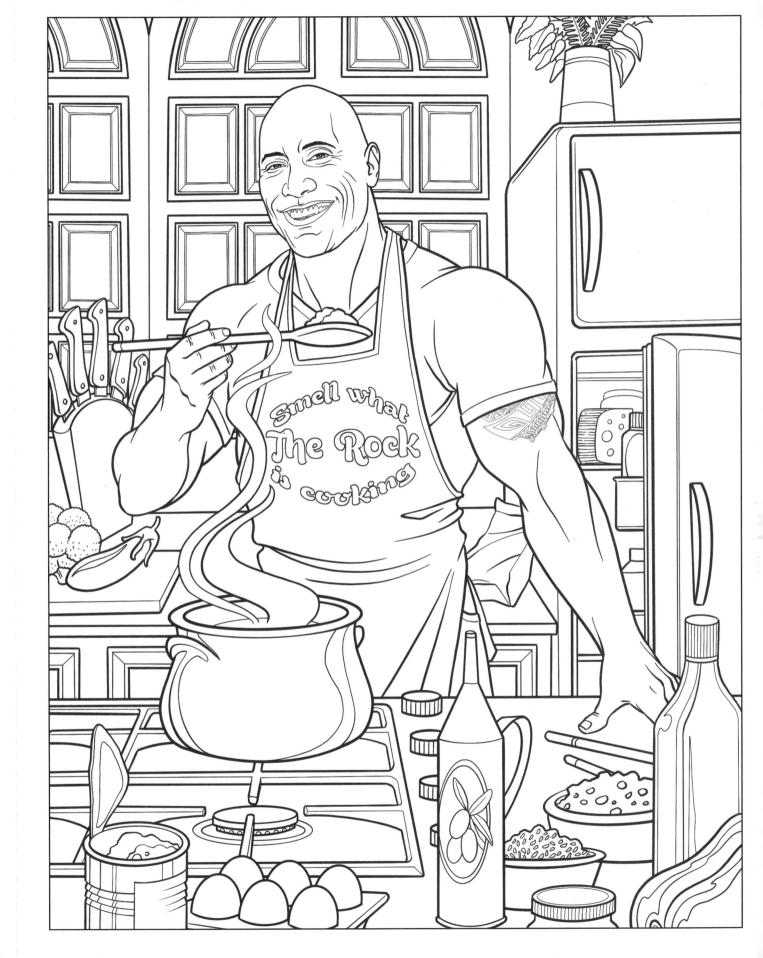

In Your Dreams

The Rock is looking sharp in his three-piece suit, but it's his sharp mind that's really something to be treasured. As he loses himself in his erudite pursuits, he could be journaling his deepest emotions, scrawling an epic poem, or jotting down inspiration that will lift the hearts and minds of a generation. The mysteries of his imagination are his to explore, and he'll craft the perfect words to describe them on these pages.

CRUSH ON THIS KNOWLEDGE

After being cut from the Calgary Stampeders football team, Dwayne flew to Florida to meet up with his dad. He had dreamed of making millions in pro football but realized during the car ride he had only $7 to his name. Today, his production company is called Seven Bucks Productions.

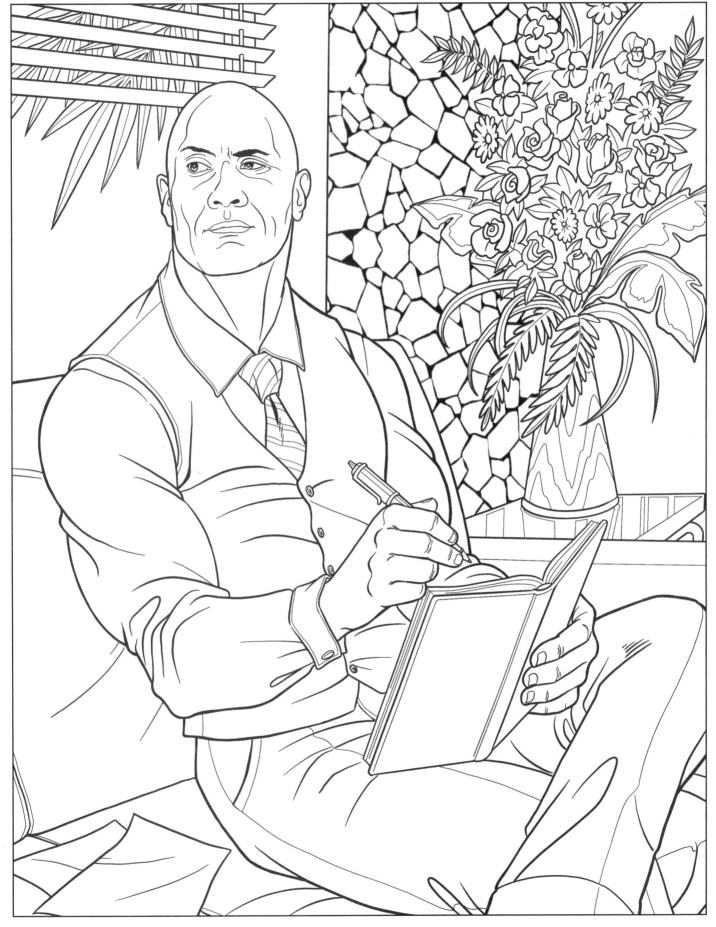

○ ○ ○ ○ *In Your Dreams* ○ ○ ○ ○

Is that a cool breeze in the air, or is that just The Rock's ultra-cool stare? He may be made of muscle, but the muscle he flexes better than all the rest is his mind. As the wind sends his hammock swaying, he is deep in thought and devouring the contents of the pages before him. Like any Renaissance Man, even his days off are ripe with curiosity and stimulation. Inquiring minds want to know just what he's thinking, but he'll save those secrets for you.

CRUSH ON THIS KNOWLEDGE

Dwayne is an avid reader, often switching among multiple books at a time. One of his favorites, which he often recommends, is *Outliers* by Malcom Gladwell. He's also tried his hand at the book business, penning a memoir, *The Rock Says*, which was published in 2000.

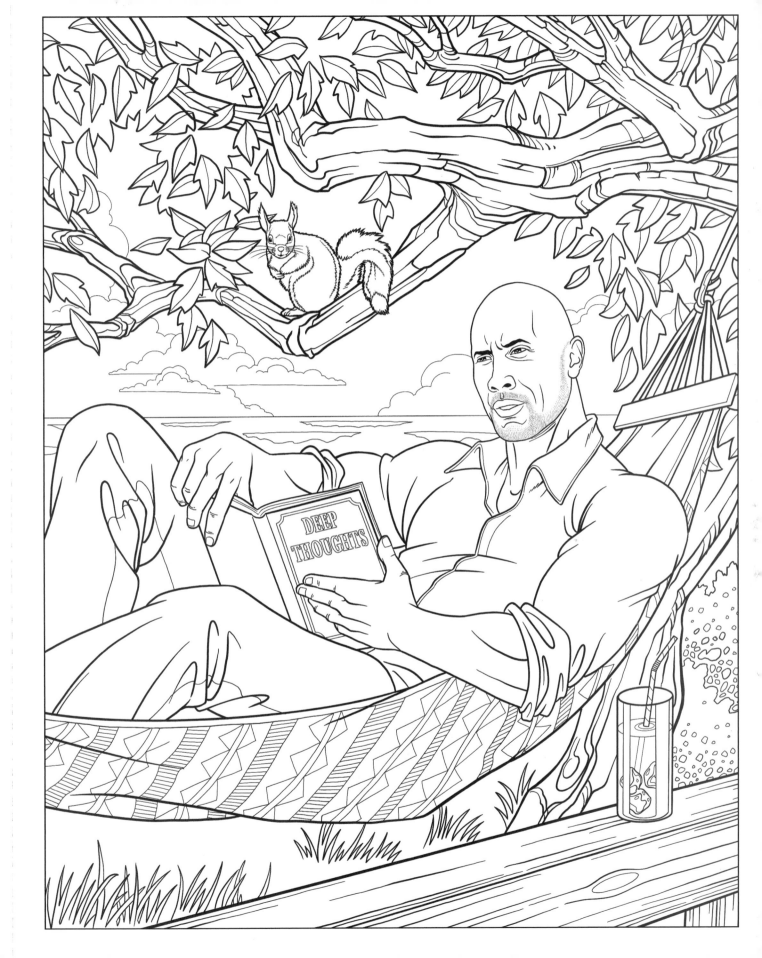

○ ○ ○ ○ *In Your Dreams* ○ ○ ○ ○

There's an addition to this metropolitan skyline, and he is monumental. While his towering physique is sure to impress anyone who crosses his path, it's his easy grin that will stand the test of time. This laid-back charmer's beaming smile comes readily and naturally, and he'll brighten anyone's day when he flashes its mesmerizing sparkle. Capture a glimpse of him while he's cheesing, and you'll never have a reason to frown.

CRUSH ON THIS KNOWLEDGE

At the London premiere of his film *San Andreas* in 2015, Dwayne set a Guinness World Record for most selfies taken in three minutes. Officials had to ensure that each was in focus and included the full face and neck of the subjects, resulting in 105 qualified selfies.

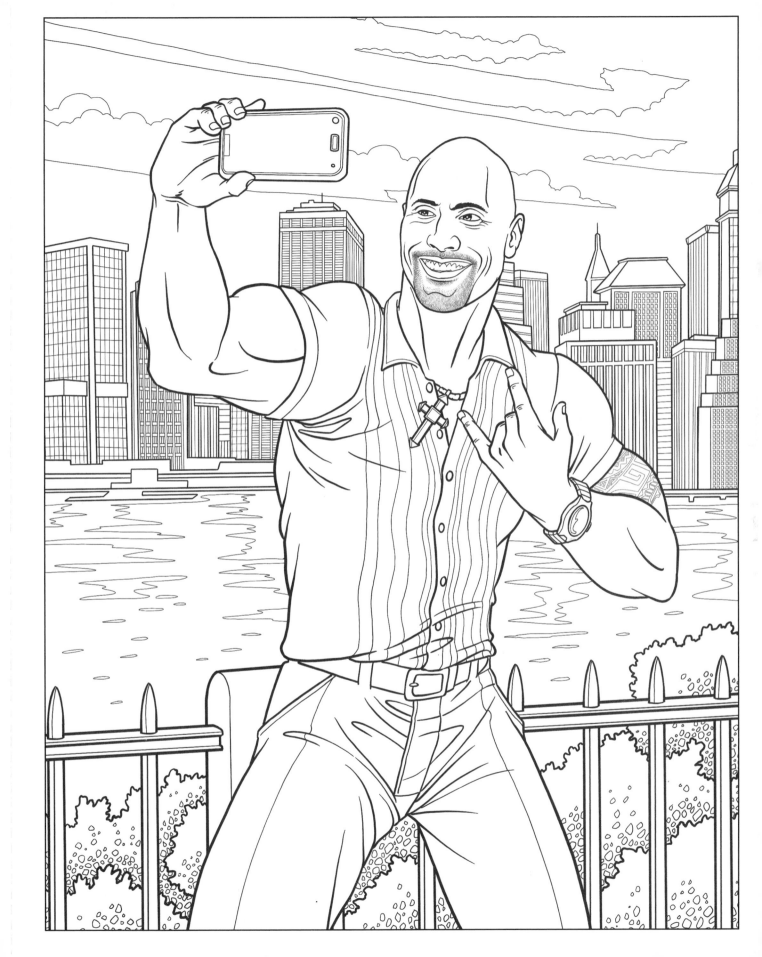

○ ○ ○ ○ *In Your Dreams* ○ ○ ○ ○

There are always fireworks when The Rock is around. As they burst above him and glimmering flecks of light fall, he'll glow with the optimism of a man who knows that he can make a difference. He stands up for equality and doesn't just pursue his own happiness, but scatters it wherever he goes. A man who manifests the most ambitious of dreams is sure to send hearts fluttering.

CRUSH ON THIS KNOWLEDGE

Every episode of Dwayne's sitcom, *Young Rock*, begins and ends with him (playing himself) being interviewed during a fictitious 2032 run for president. This is no coincidence—he's said multiple times that he's interested in political life, including a possible presidential run down the road.

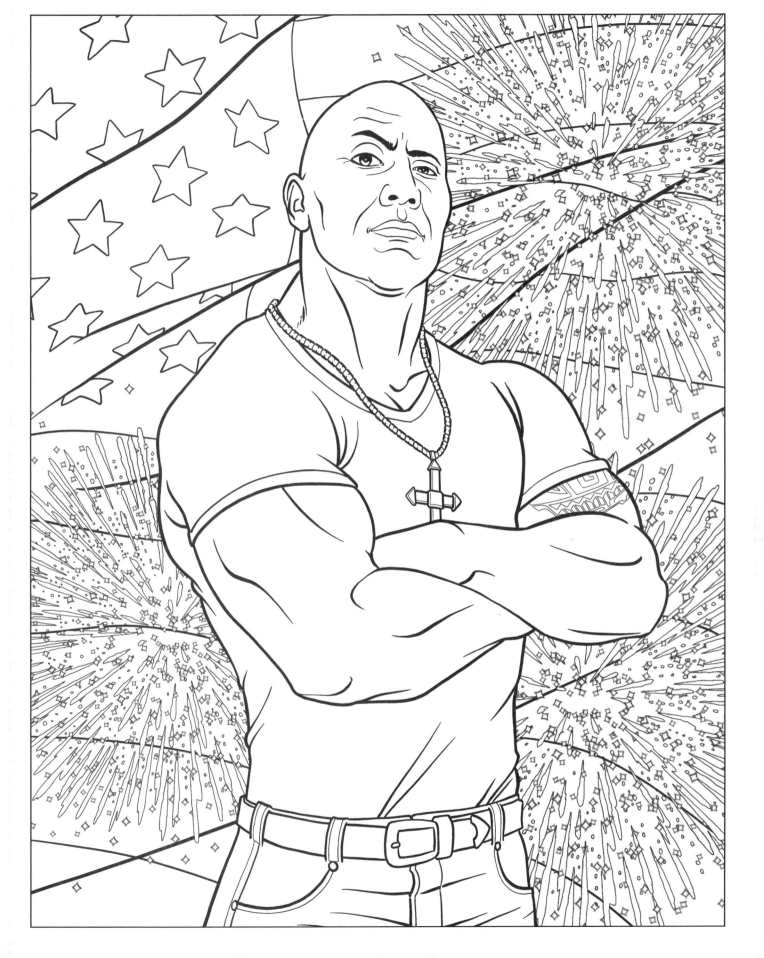

○ ○ ● ○ *In Your Dreams* ○ ○ ● ○

Giddy-up for this wild ride. The Rock may be racing along these desert hills to right a wrong, to come to a weary wanderer's aid, or to make it home to you before the sun sets. Whatever the reason for his breakneck pace, you know this loyal stallion will never disappoint. Watch his fierce determination as he rides like the wind and let the clatter of hooves play like music to your ears.

CRUSH ON THIS KNOWLEDGE

Having lived everywhere from Nashville to New Zealand, including Hawaii and Canada, Dwayne is a man of the world. But he's a country boy at heart, which you can tell from his love of country music and the gorgeous horse farm he calls home in Virginia.

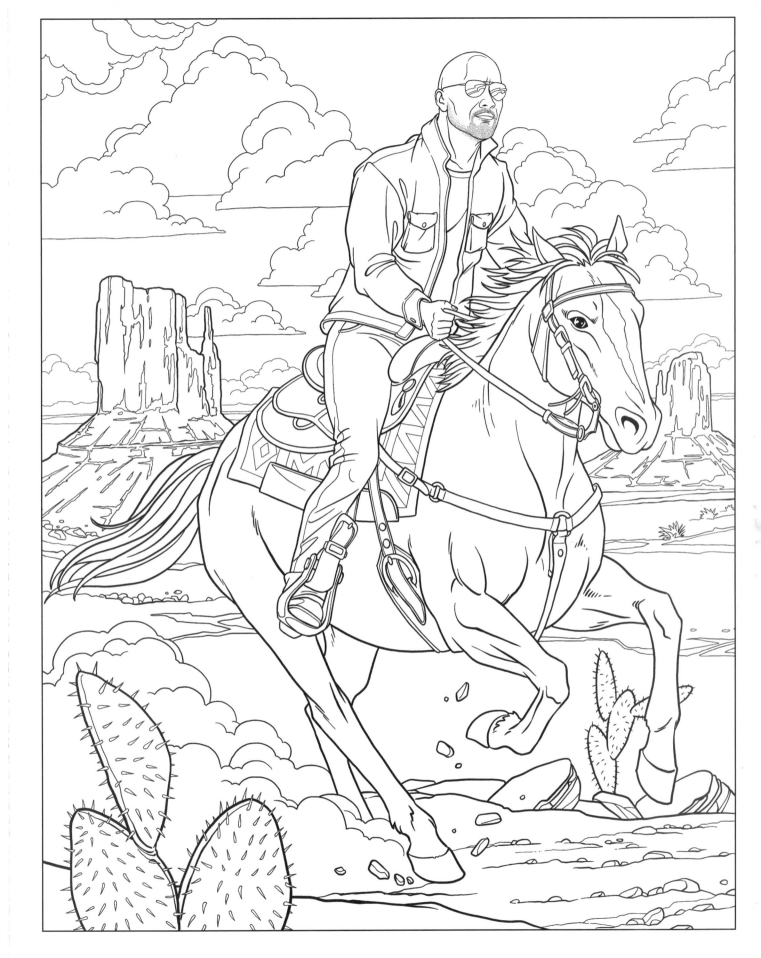

○ ○ ○ ○ *In Your Dreams* ○ ○ ○ ○

It's not a Titan holding up the Earth, it's just The Rock doing his morning workout. The boulders around him crumble at his will because they know they have met their maker. But his extraordinary might isn't just for show—he will move mountains if you ask him to, just as he can lift the spirits of anyone who is down. Marvel at his impressive strength that goes beyond his stunning physique, and fall in love with the softness of his heart.

CRUSH ON THIS KNOWLEDGE

Dwayne has worked hard on his incredible physique, but he was also an early bloomer. By the time he was 16 years old, he was 6'4" and 225 pounds. His high school classmates actually believed he might be an undercover cop because of his imposing size and burgeoning mustache.

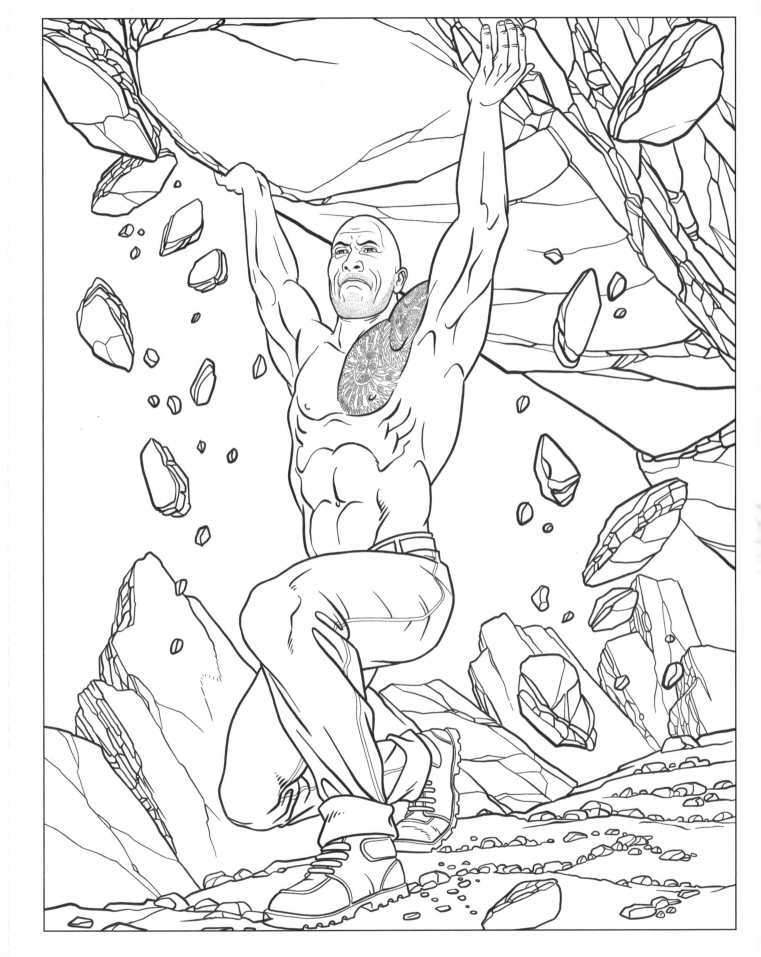

○ ○ ○ ● ○ *In Your Dreams* ○ ○ ○ ● ○

One would imagine that a man with hulking strength might not be light on his feet, but on this dance floor, The Rock will twirl any ballroom partner with such elegance that it will feel like a whimsical fairytale. As he whirls along to the music, he'll show a tenderness and grace that will surprise you. Dressed to kill but poised to impress, this shining star will glide across the dance floor and leave everyone else in the dust.

CRUSH ON THIS KNOWLEDGE

In 2018, Dwayne responded to a young girl who invited him to prom by making the morning announcements at her school. Although he had to decline due to scheduling, he did rent out a local theater for the students to see *Rampage* early and with unlimited popcorn and beverages.

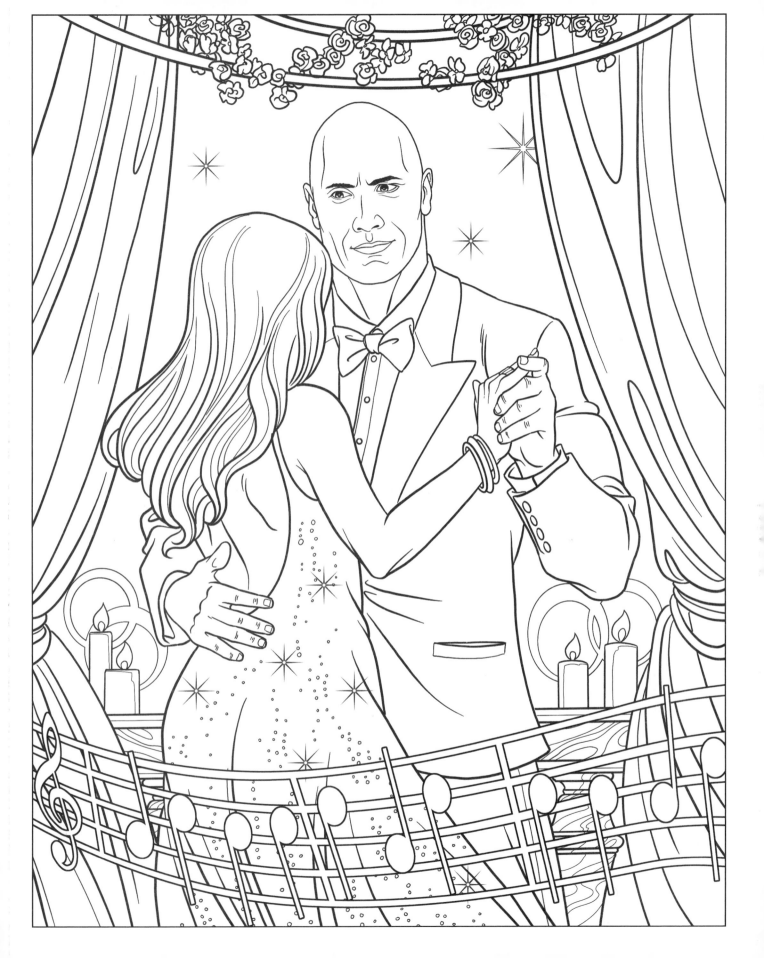

○ ○ ○ ○ In Your Dreams ○ ○ ○ ○

What's in a name? The Rock doesn't shy away from any challenge, and he'll find himself closely connected to this stony cliffside. As he scales the unbreakable surface that shares his name, he'll strive to be the best version of himself. Watch him ascend to the height of perfection, and gaze in wonder at his fearless pursuit of excellence. Look out below to see the world from a star's-eye view.

CRUSH ON THIS KNOWLEDGE

One of Dwayne's many talents is finding ways to inject his own comedic style into his projects. While preparing for 2017's *Jumanji: Welcome to the Jungle*, he texted executive producer Jake Kasdon with the idea of naming his character "Smolder" and giving him the ability to smolder within the game.

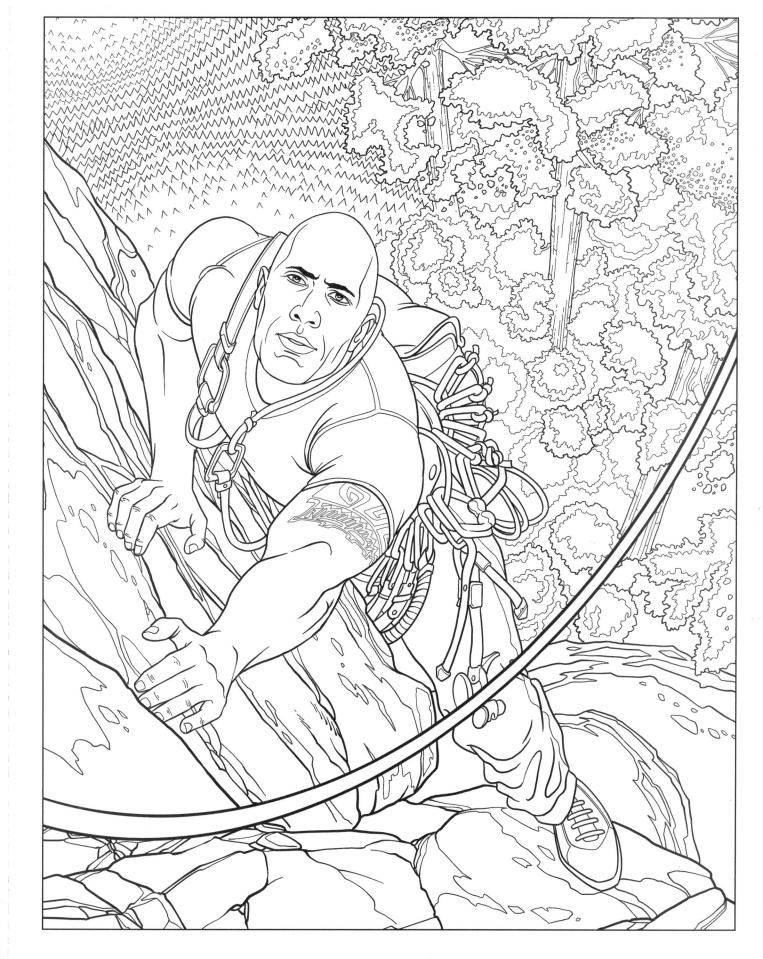

∘ ∘ ∘ ∘ *In Your Dreams* ∘ ∘ ∘ ∘

There's never a dull moment when The Rock is in charge, and today he's cruising for some action along the waterfront of this coastal city. When he's suited up and his shades are on, you know he means business. Buckle up and get ready for the ride of your life, because he's going from zero to 60. Bound along the sandy beaches on this mission to save the day, and let him take the wheel when things get rough.

CRUSH ON THIS KNOWLEDGE

Dwayne's canine bestie, Hobbs, made a cameo in the movie he was named for, *Hobbs and Shaw.* You can see the French bulldog lying on the bed in an early scene while Dwayne does pushups below. The pup's loving owner jokes that the fame has gone to his head.

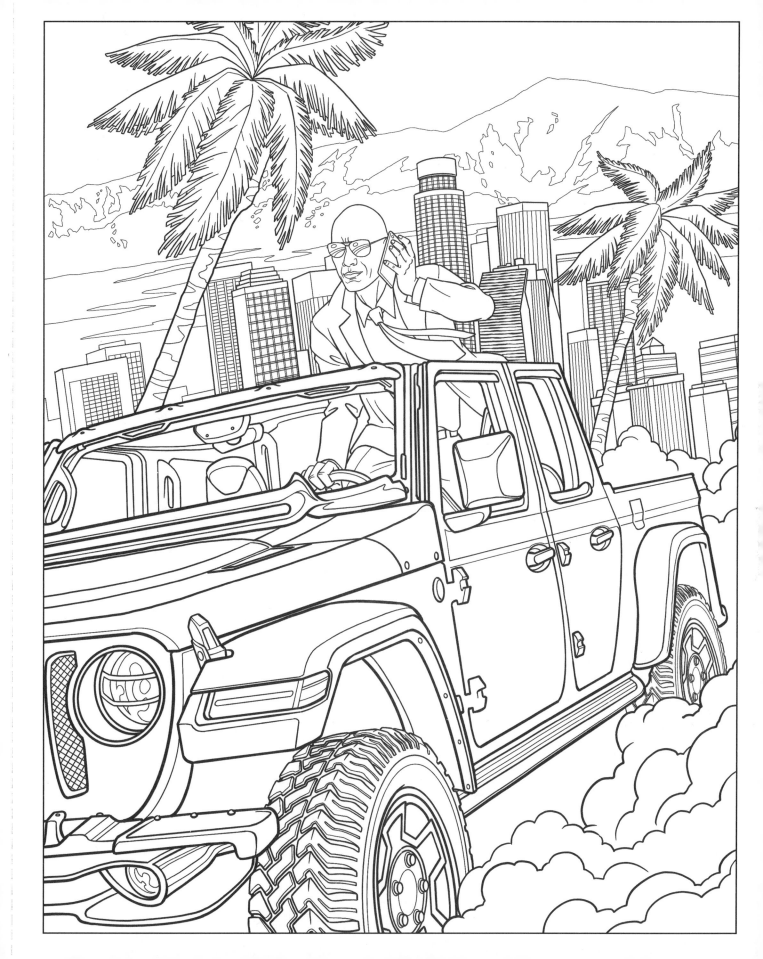

○ ○ ○ ○ *In Your Dreams* ○ ○ ○ ○

If you think The Rock's intensity doesn't extend to his leisure time, you are mistaken. Imagine a sun-kissed afternoon on a blissful shore with this impeccable man. He's enjoying the view of the flourishing tropics and unwinding with some meditative pec-popping, but not before perfecting his sandcastle kingdom. Poseidon himself would bless the gates of this sandy structure, and mermaids would grace its shores. The waves crash in approval and the seagulls caw at a job well done, and The Rock can relax in satisfaction with another flawless day.

CRUSH ON THIS KNOWLEDGE

Dwayne is the kind of man whose boundless joy and optimism make him feel comfortable anywhere and with anyone. He considers Presidents Bill Clinton and George W. Bush "buddies" and has met with Barack Obama several times. While friends call him DJ, President Obama still calls him "The Rock."

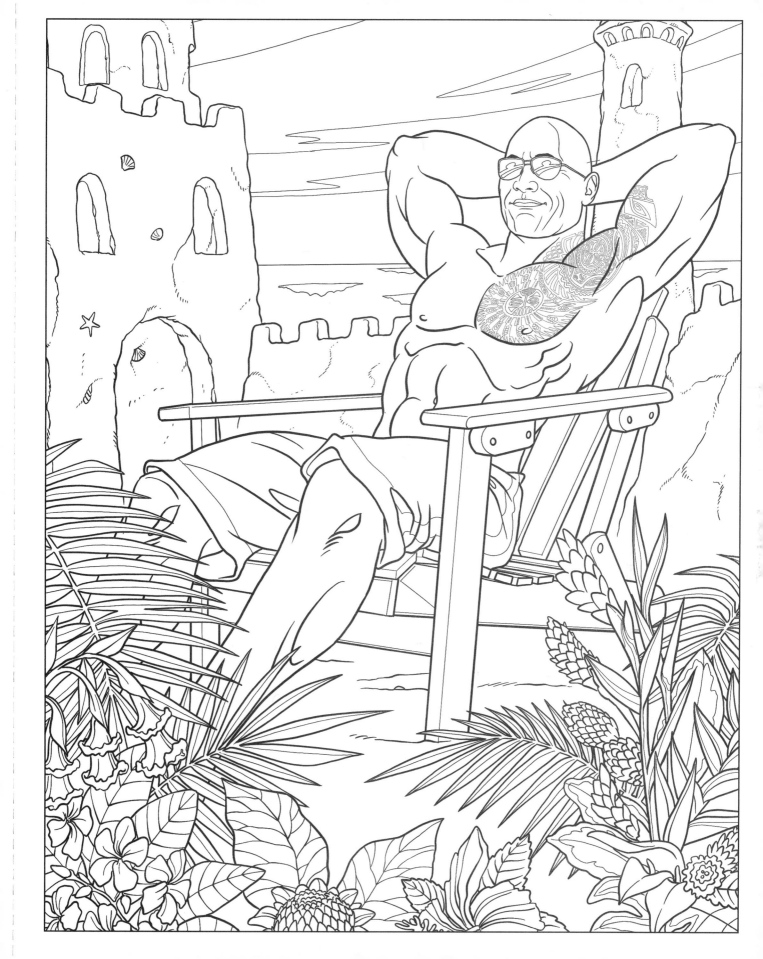

○ ○ ○ ○ *In Your Dreams* ○ ○ ○ ○

Soar to extreme heights with The Rock as your guide. This chopper is headed for a wondrous utopia, and he knows just how to get you there. He'll zip through the air and zoom along the scenery, but make sure to hover over cloud nine. The Rock is sure and steady in his command of this chopper; while he'll make sure to thrill you the whole way, he'll be certain to go in for a landing that leaves you feeling safe and secure.

CRUSH ON THIS KNOWLEDGE

In a scene in 2015's *San Andreas*, Dwayne's character rappels out of a helicopter hovering 150 feet above the ground to rescue a woman from a car that hangs from a cliffside 50 feet above the ground. Although the helicopter was stationary, Dwayne's stunt work was real.

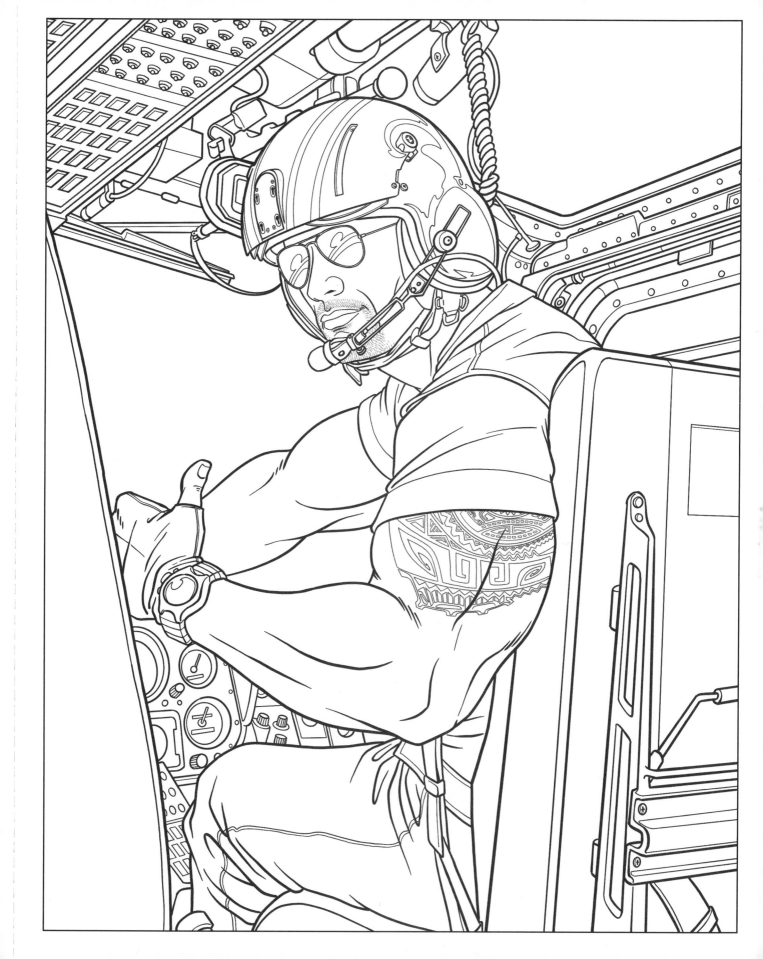

∘ ∘ ∘ ∘ *In Your Dreams* ∘ ∘ ∘ ∘

The Rock brings all new meaning to the term "star power." Whether it's the power of his frame, the power of his gaze, or the power of his incandescent smile, The Rock does more than just shine. He would soar across the night sky with his starlight if he could, but his radiant positivity has greater effect. Let his optimism shimmer and his good nature cast its glow far and wide, because he is one source of light that will never burn out.

CRUSH ON THIS KNOWLEDGE

Dwayne's Hollywood success was a part of a calculated 10-year plan. He quietly began retiring from wrestling at the age of 29 while studying acting and working with coaches. "I wanted to have a real long-lasting career that had weight, that had value," he says.

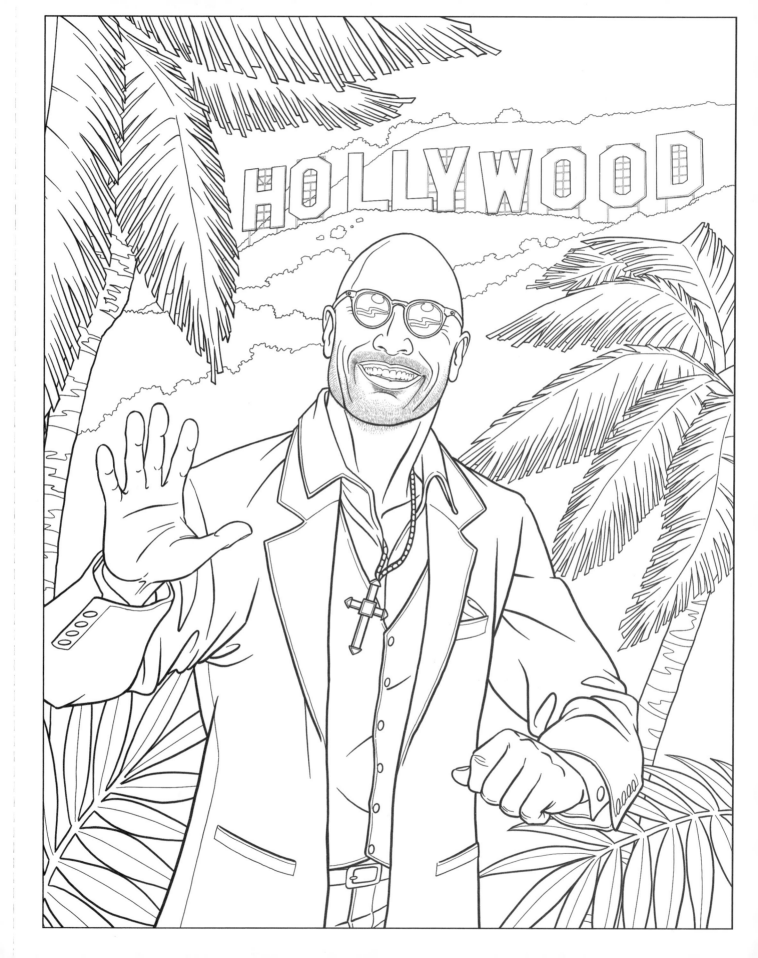

○ ○ ○ ○ *In Your Dreams* ○ ○ ○ ○

There's no need for a life raft when The Rock's buoyant personality is keeping everyone afloat. He's already in vacation mode and the water is warm, so take a dip or dive right in. Drift along in this tranquil pool and let your cares sail away because you have The Rock by your side. The Rock's boisterous laugh and sunny disposition will remind you that there is no day that can't be made better.

CRUSH ON THIS KNOWLEDGE

An appearance on Saturday Night Live in 2000 helped Dwayne break out of his wrestling persona and reach a wider audience. The opportunity was born of WWE CEO Vince McMahon persuading Lorne Michaels to give Dwayne a shot. He proved that he had comedic chops, good timing, and universal appeal.

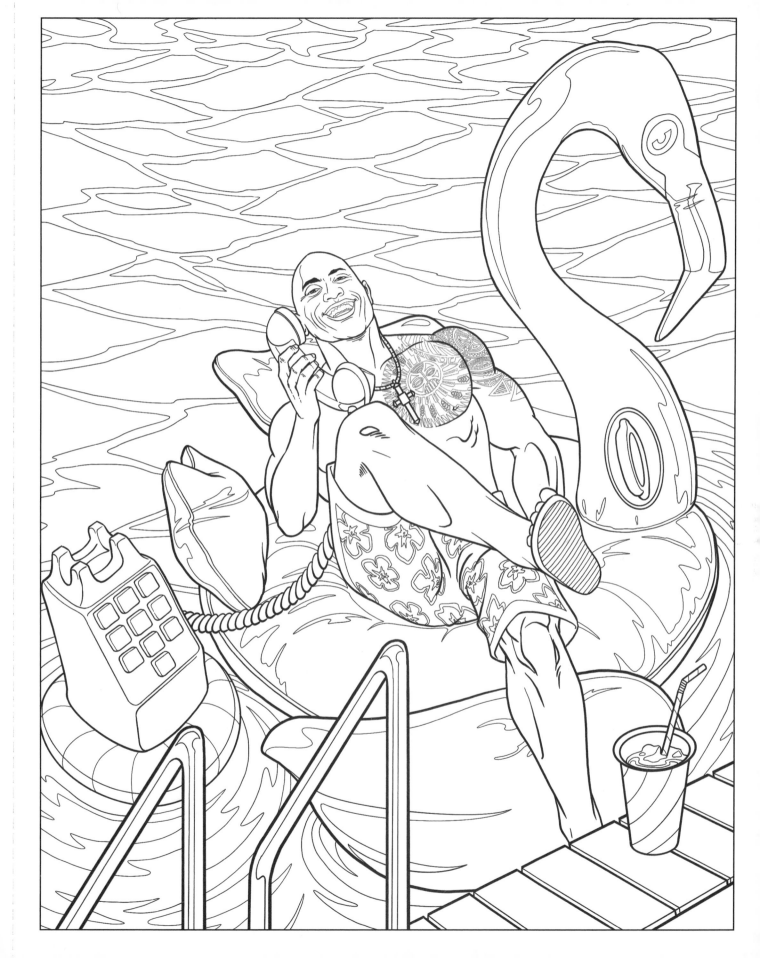

○ ○ ○ ○ *In Your Dreams* ○ ○ ○ ○

Hop on the back of The Rock's motorcycle and let him take you for a spin. Hold on tight as he coasts along every curve and enjoy the thrill of his roaring engine. Feel the power of man and machine and let the blur of the scenery fill your vision. As the wind whips through your hair and he grasps the handles for this long and winding journey, you can feel the freedom of the open road and joy in your heart.

CRUSH ON THIS KNOWLEDGE

Dwayne thought his dream of joining the Central Intelligence Agency (CIA) was crushed when his criminal-justice professor and advisor told him his best chance with the agency was with a law degree, which he didn't have the grades to pursue. Fast forward to 2016's *Central Intelligence*, and he got to act out his dream for audiences everywhere.

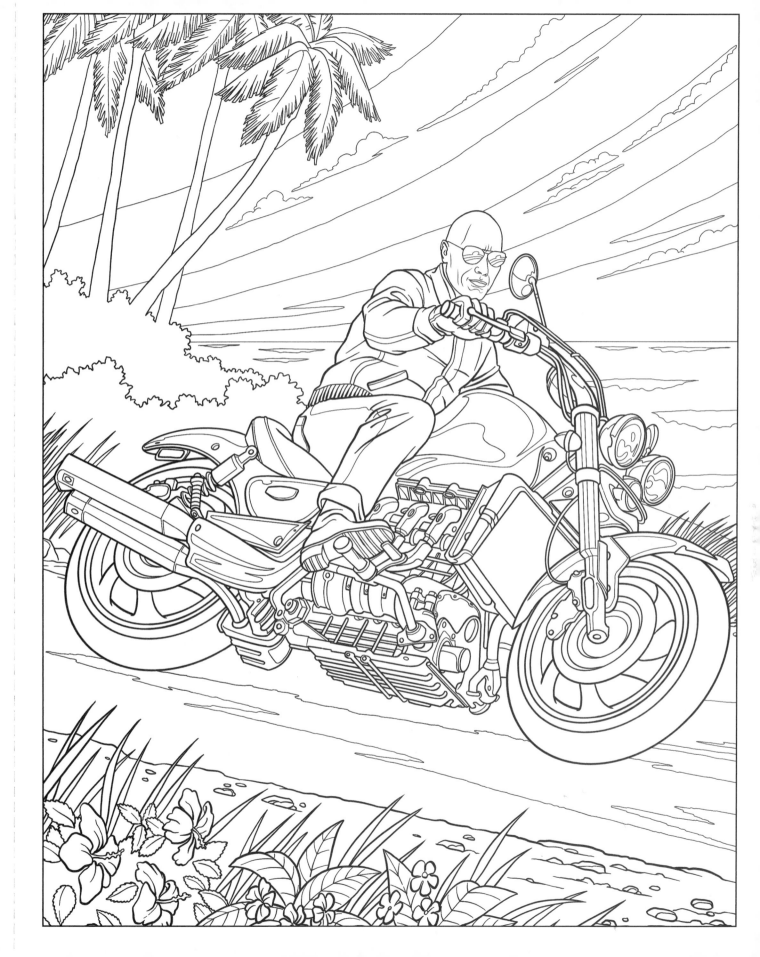

○ ○ ○ ○ *In Your Dreams* ○ ○ ○ ○

They say the camera adds 10 pounds, but on The Rock it's just his 10-pack. There's no challenge too great for this hulking thespian, and he will bring the action along with the lights and camera because that's what chivalrous gentlemen do. Feel the adrenaline as he turns each scene into cinematic glory—whether by exuding his cheerful charisma, flashing his charming smile, or being quick with his wit. Let the clapperboard and your dreams snap to attention as The Rock comes onto the scene.

CRUSH ON THIS KNOWLEDGE

After starring in family-friendly films like *Tooth Fairy*, Dwayne worried that his 10-year plan for success was getting off track. He switched talent agencies in 2011, going on to join the cast of *Fast Five* and make blockbuster films like *San Andreas* and *Jumanji: Welcome to the Jungle*.

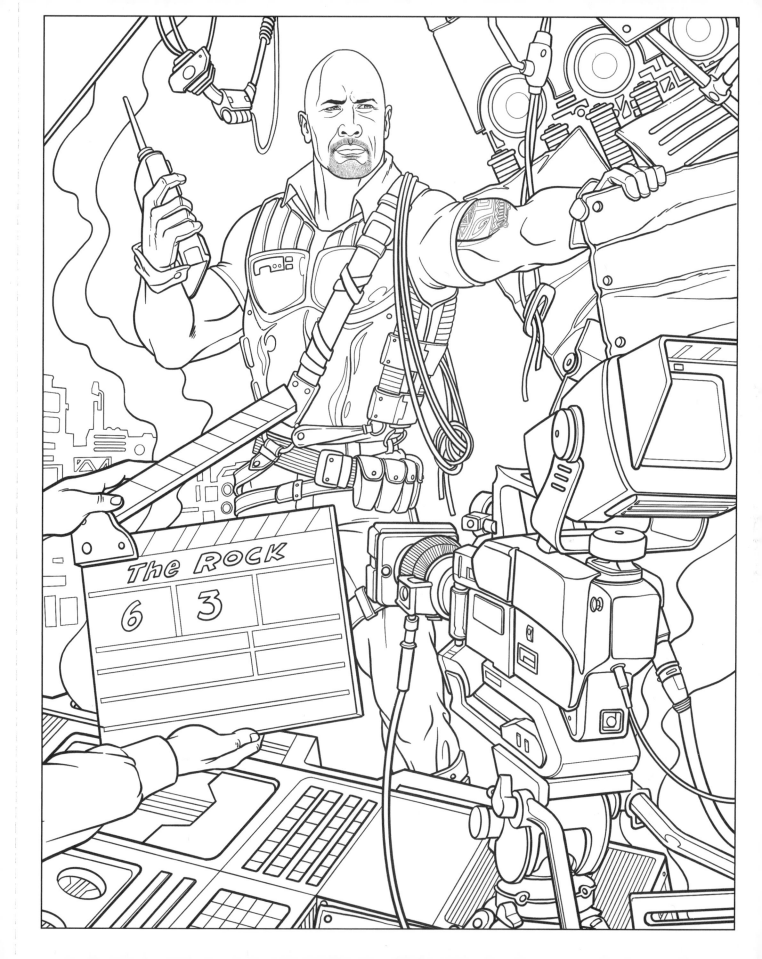

⚬ ⚬ ⚬ ⚬ *In Your Dreams* ⚬ ⚬ ⚬ ⚬

Being one of the most beloved celebrities in the world is tough business, but The Rock doesn't let the fame go to his head. In the blink of an eye, he can go from breaking paparazzi flashbulbs with a stunning smile and helping little old ladies cross the street to single-handedly saving the universe from destruction. His heart is as big as his celebrity and he wins the award for Most Crushable.

CRUSH ON THIS KNOWLEDGE

Dwayne didn't just set out to be a great actor, he worked hard to be a star. "I wanted to be the number-one man in the world of Hollywood in terms of box office draw," he says. In 2017, he was honored with a star on the Hollywood Walk of Fame.

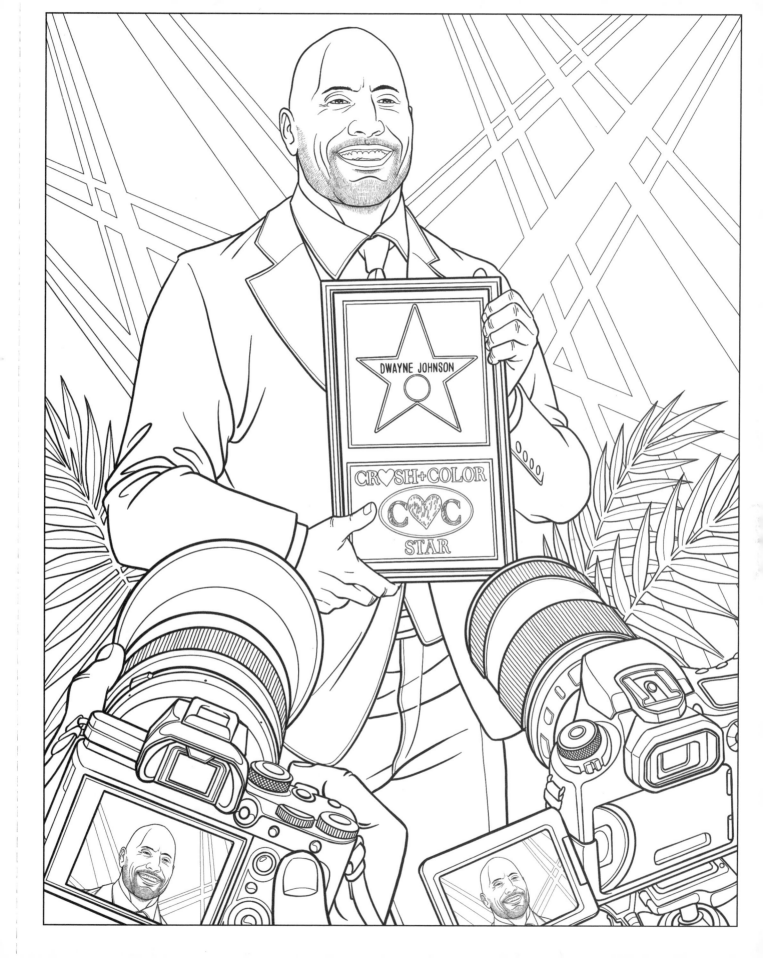

In Your Dreams

The buzz of a tattoo gun might send some people running, but it's a melody to The Rock's ears. He is already a work of art to anyone paying attention, but his canvas is ever-changing and gets better with age. He'll sit in that parlor chair like a champion, because to him, the bite of the tattoo needle feels like a gentle tickle. Watch him smile his way through his next session without a care in the world.

CRUSH ON THIS KNOWLEDGE

In 2017, Dwayne visited LA tattoo artist Nikko Hurtado to transform the small bull tattoo he got in the mid-90s during his wrestling days. Of the expansion, he said, "I got this tattoo when I was just a kid. Now I need it to reflect me as a man."

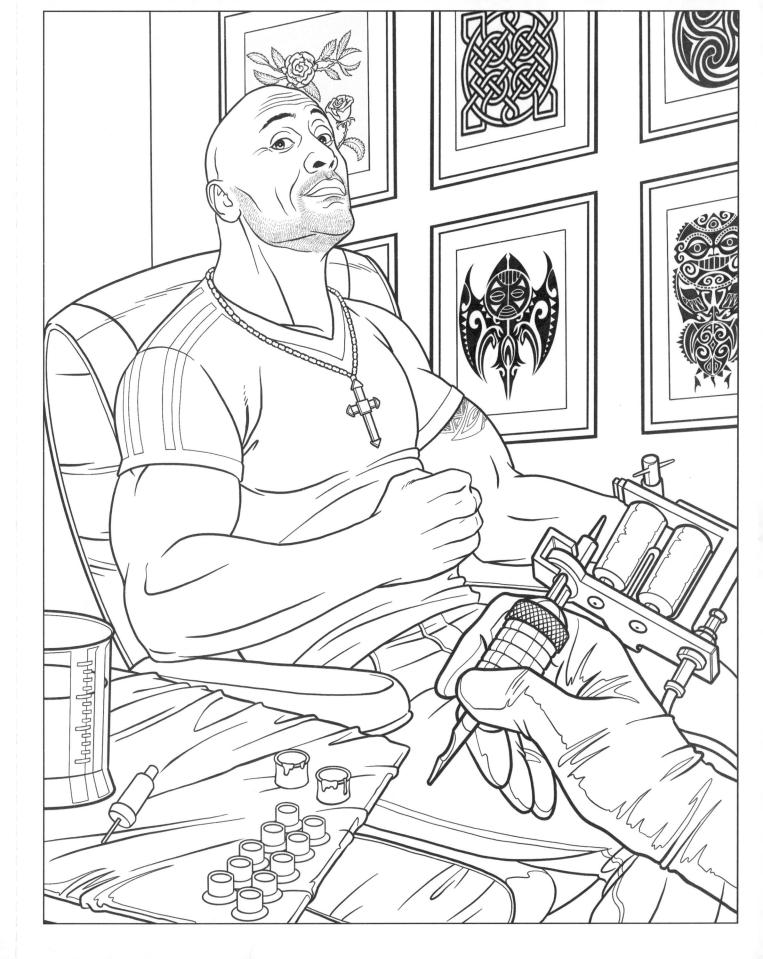

○ ○ ○ ● ○ ***In Your Dreams*** ○ ○ ○ ● ○

Rock out to The Rock, and he might just blow your mind. Whether he's strumming a ukulele with a soothing song on his lips or making the room pulse with an electric guitar, he is sure to make the crowd go wild. He'll flick his fingers along the strings with expert precision, nailing every note to your favorite song. Let the music wash over you and revel in his rhythm as he performs on the stage of this fantasy show.

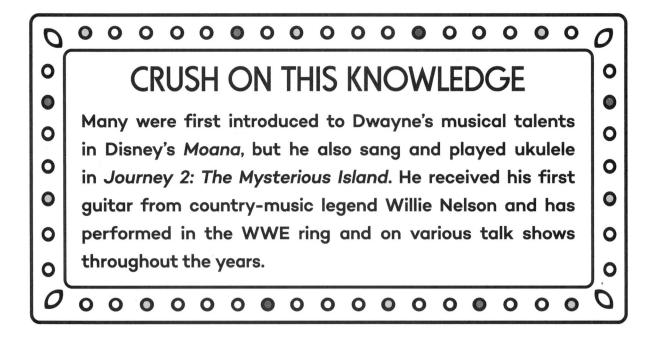

CRUSH ON THIS KNOWLEDGE

Many were first introduced to Dwayne's musical talents in Disney's *Moana*, but he also sang and played ukulele in *Journey 2: The Mysterious Island*. He received his first guitar from country-music legend Willie Nelson and has performed in the WWE ring and on various talk shows throughout the years.

○ ○ ○ ○ *In Your Dreams* ○ ○ ○ ○

Some cars may look luxurious, but any driving machine that doesn't have The Rock at the wheel is just a hunk of metal. Kick into high gear as The Rock selects this pristine sports car. Sink into the seats and let the opulence of The Rock's chariot hold you in a comforting embrace. Feel the rev of the engine and get ready for a breathtaking cruise. With his sure grip on the wheel and the purring car in his control, this gallant legend will have you traveling to parts unknown.

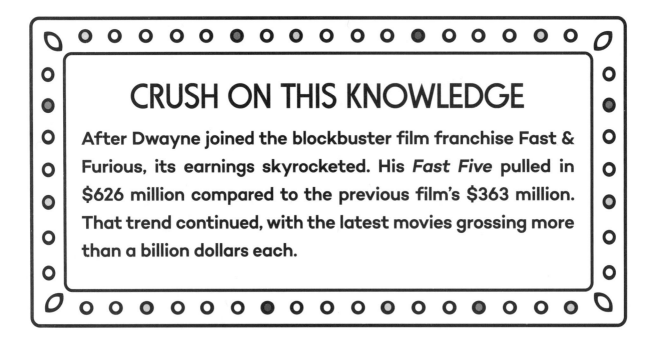

CRUSH ON THIS KNOWLEDGE

After Dwayne joined the blockbuster film franchise Fast & Furious, its earnings skyrocketed. His *Fast Five* pulled in $626 million compared to the previous film's $363 million. That trend continued, with the latest movies grossing more than a billion dollars each.

⚬ ⚬ ● ⚬ *In Your Dreams* ⚬ ⚬ ● ⚬

It's tea time with Hollywood's most beloved sweetheart. A regular afternoon becomes a charming fairy tale feast when The Rock is at the table. He'll nibble on treats and pour a dainty spot of tea to bring happiness to his teatime companions, because that's what real men do. Giggle the day away with the loveliest of parties, listen to the melodies of birds that have stopped by to sing you their song, and feel warmth in your heart because these simple pleasures are all he needs.

CRUSH ON THIS KNOWLEDGE

Family is everything to Dwayne. He has three daughters—Simone with his first wife, Dany Garcia; and Jasmine and Tiana with his now wife, Lauren Hashian. Dany continues to manage Dwayne's career to incredible success while her brother, Hiram, acts as his producing partner and her husband, Dave Rienzi, works as his conditioning coach.

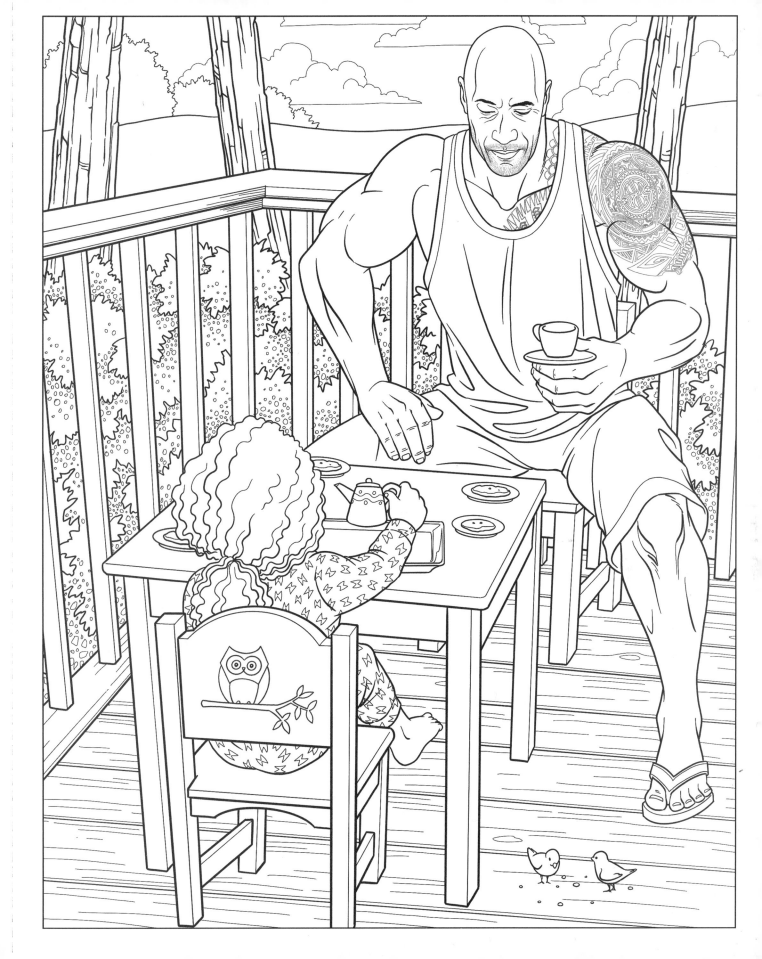

○ ○ ○ ○ *In Your Dreams* ○ ○ ○ ○

Up and at 'em—it's bright and early and The Rock is ready to rumble. Lucky for you, he's foraged for the freshest ingredients, climbed the tallest trees to pluck fruit from their branches, and hand-blown the glassware that will hold your beverage—all before sunrise. As he tosses the perfectly ripe fruit and precious vegetables into the blender, you'll wonder if their natural sugars could possibly make this man any sweeter.

CRUSH ON THIS KNOWLEDGE

As a dedicated bodybuilder and an action star, it's important that Dwayne eat healthy, protein-rich meals. A typical day can include steak, chicken, fish, egg whites, oatmeal, protein shakes, and orange juice. But his cheat days are epic, featuring things like pancakes, pizza, sushi, doughnuts, and cheesecakes.

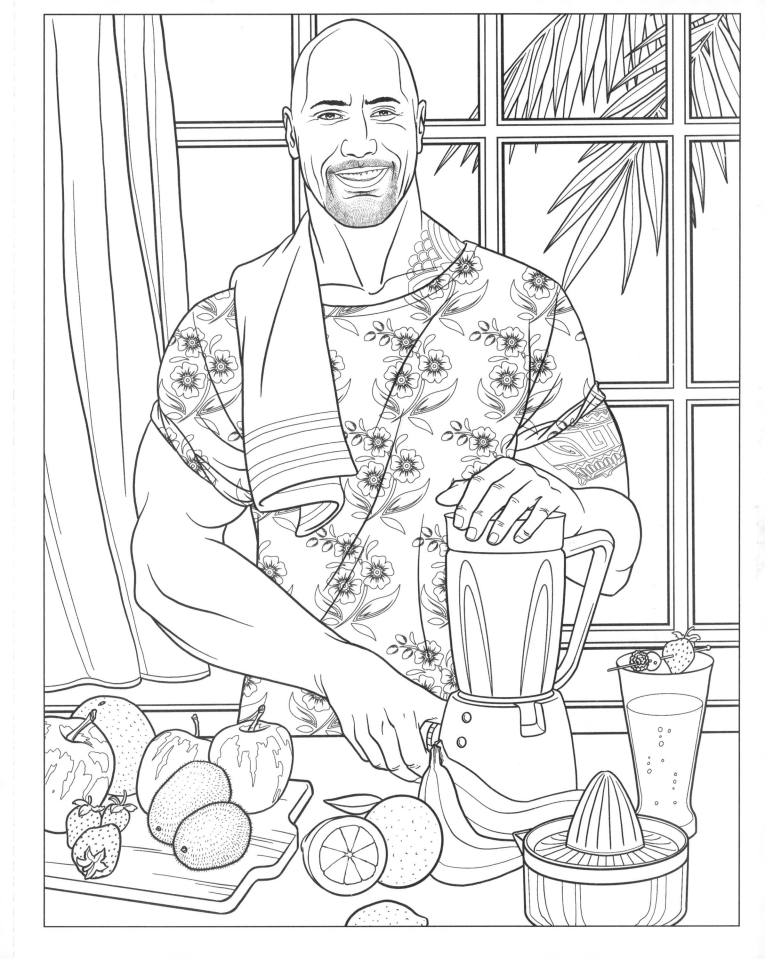

○ ○ ○ ○ *In Your Dreams* ○ ○ ○ ○

Enter this field of dreams and find a glorious floral haven. As The Rock strolls through this fertile ground bursting with sunflowers, the impressive blossoms lean in to feel the power of his rays. He'll saunter along with gentleness as he thinks deeply about the universe, being careful not to bend a single petal. The Rock's source of brilliance and light might just be in these meadows, or maybe he himself is the source.

CRUSH ON THIS KNOWLEDGE

Although the Dwayne Johnson we know today has a sunny disposition and megawatt smile, Dwayne struggled with depression throughout his earlier years. The first of three especially low periods came after receiving a shoulder injury while playing college football, resulting in his temporarily dropping out of school.

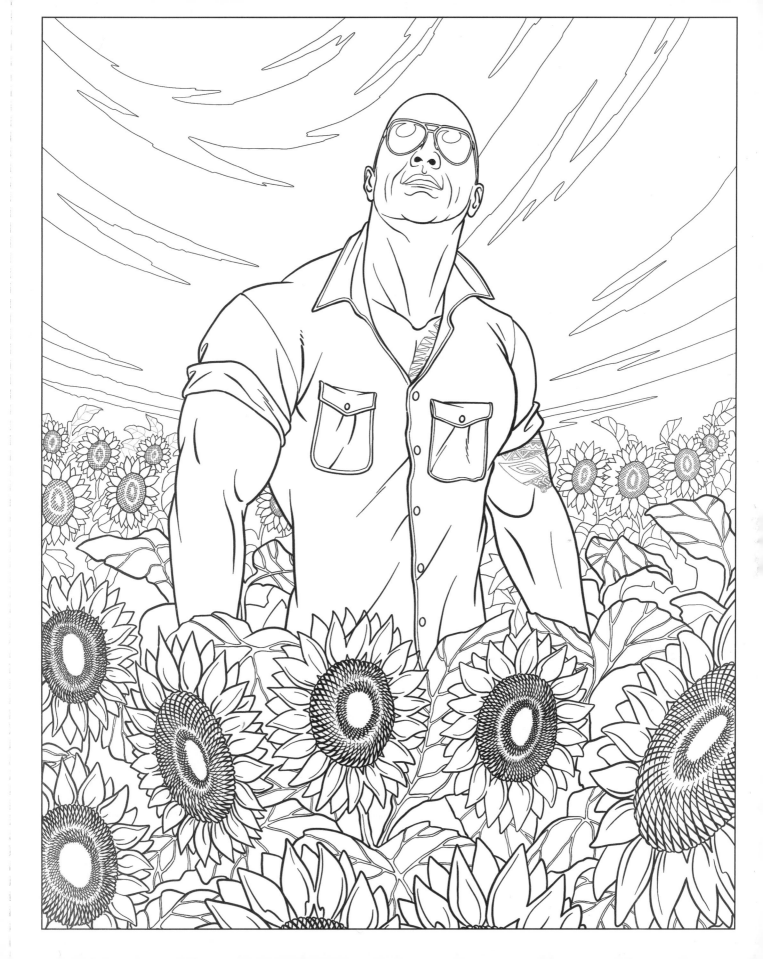

○ ○ ○ ○ *In Your Dreams* ○ ○ ○ ○

Sail away to an island paradise with The Rock at the helm. He could navigate by starlight on a romantic evening or listen to the whispers of the wind on a breezy morning, but there is no sea so vast or storm so big that it could send him off course. He'll use his unparalleled strength to steer the skiff and ward off invaders, but it's his magic smile and quick wit that will make this journey worthwhile.

CRUSH ON THIS KNOWLEDGE

Dwayne has starred in a couple of live-action Disney movies, but he had always wanted to voice a character in one of their animated films. Having a deep respect for the work of voice actors, he continually asked for their feedback when portraying Maui in 2016's *Moana*.

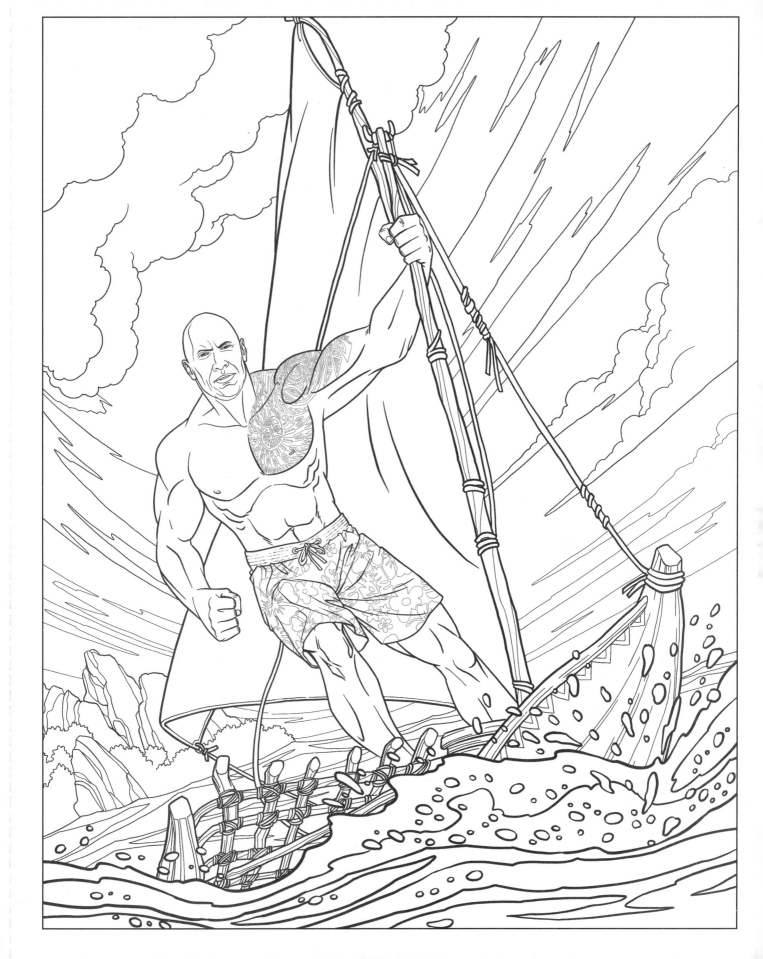

In Your Dreams

There's no task too daunting for Dwayne "The Rock" Johnson. Kitten caught in a tree? Let The Rock fly in with a team of helicopters, blow through the obstacles in his way, and parachute down to the tree line to save this baby feline. He'll make a spectacle, because this kitten is special, and he'll do it in a sharp suit to prove destruction doesn't have to be a disaster.

CRUSH ON THIS KNOWLEDGE

When he was trying to transition from wrestling to film, Dwayne was told he needed to slim down to look more like other leading men if he wanted to be successful. He followed the advice but ultimately realized that being his authentic self would take him further. And it did.